THE HOLY COW
AND OTHER ANIMALS

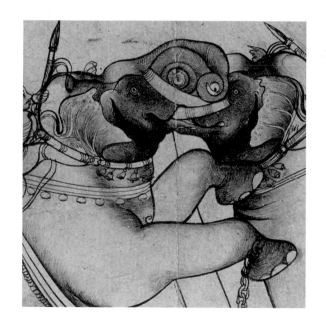

THE HOLY COW

THE ART INSTITUTE OF CHICAGO

Distributed by

THE UNIVERSITY OF WASHINGTON PRESS

AND OTHER ANIMALS

A Selection of Indian Paintings

FROM THE ART INSTITUTE OF CHICAGO

PRATAPADITYA PAL *and* BETTY SEID

This book was published in conjunction with the exhibition "The Holy Cow and Other Animals: A Selection of Indian Paintings from The Art Institute of Chicago," organized by The Art Institute of Chicago and presented from February 9 to June 1, 2002.

First edition
Printed in the U.S.A.

06 05 04 03 02 9 8 7 6 5 4 3 2 1

Published by
The Art Institute of Chicago
111 South Michigan Avenue
Chicago, Illinois 60603-6110

Distributed worldwide by
The University of Washington Press
P.O. Box 50096
Seattle, Washington 98145-5096
800-441-4115

ISBN 0-86559-196-2

Library of Congress Control Number:
2001098290

Produced by the Publications Department of The Art Institute of Chicago, Susan F. Rossen, Executive Director
Edited by Catherine A. Steinmann
Production by Sarah E. Guernsey
Designed by Brockett Horne and Nicole Eckenrode
Photography by Gregory A. Williams, Department of Imaging, Alan B. Newman, Executive Director
Separations by Professional Graphics, Inc., Rockford, Illinois
Printed and bound by Meridian Printing, East Greenwich, Rhode Island

Note to the Reader: The full dimensions of each work are given in the captions in the Catalogue section. Many borders have been omitted in the reproductions, however, in order to maximize the size of the central images.

FRONT COVER: Detail of *A Vaishnava Cosmological Scroll* (cat. no. 16)

PAGE 1: Detail of *Two Charging Elephants* (cat. no. 27)

PAGES 2–3: Detail of *Prince and Princess Hunting* (cat. no. 24)

CONTENTS

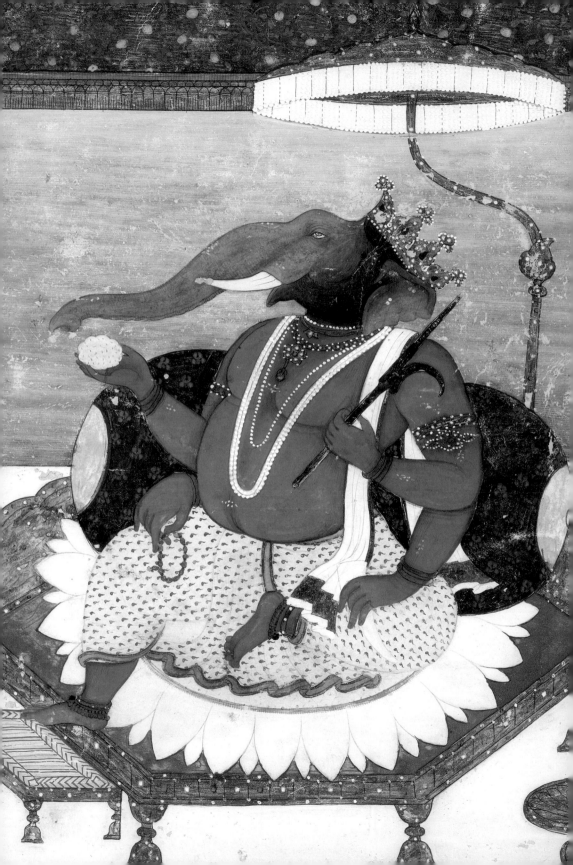

PREFACE

This beautiful and informative catalogue by Dr. Pratapaditya Pal and Betty Seid documents the first scholarly exhibition of the Art Institute's holdings of Indian paintings since the Asian art collection's beginning in 1900. This is significant for several reasons, among them the fact that the Art Institute's Asian Art collection is still widely perceived as being focused primarily on the arts of East Asia, particularly China, Korea, and Japan, and not on the arts of South and Southeast Asia. In the past seven years (since Dr. Pal's joining the museum's staff in 1995), however, this situation has been redressed with the acquisition of major works of Indian, Himalayan, and Southeast Asian art. These acquistions complement the earlier building of the South Asian collection in the early and mid twentieth century by curators Charles Fabens Kelly and Jack V. Sewell. As a result, the Art Institute can now boast one of the preeminent collections of Indian art in America.

The museum's collection of Indian painting ranges in date from the twelfth through twentieth centuries. (The earliest works are three Pala Buddhist manuscript pages, formerly in the Heeramaneck Collection and acquired at auction in 1995.) The collection began in earnest after World War I, with gifts of superb paintings from Lucy Maud Buckingham in 1919 and from Guy H. Mitchell and Emily Crane Chadbourne in 1926. Since World War II, the collection has grown even further, with purchases and generous donations from James W. and Marilynn Alsdorf, Charles C. Haffner III, Everett and Ann McNear, Dr. and Mrs. Pratapaditya Pal, the Joseph and Helen Regenstein Foundation, Herman Spertus, Russell Tyson, and Robert Walzer of the Nathan Rubin–Ida Ladd Family Foundation. Today the collection numbers well over two hundred paintings. The majority of these date to the sixteenth to nineteenth centuries and comprise works from the Mughal period and Rajput schools (including Kangra, Mewar, Bundi, Kotah, and Jaipur), Kalighat school and India Company School works, and paintings from the states of Tamil Nadu, Andhra Pradesh, Maharashtra, Orissa, and Kashmir. The theme of animals, both sacred and mundane, permeates each of these schools and regional styles, and is the unifying subject of this exhibition, providing an excellent survey of a superb yet heretofore little-known collection.

Stephen Little
Pritzker Curator of Asian Art

Detail of *Women Worshipping Ganesha*
(cat. no. 1)

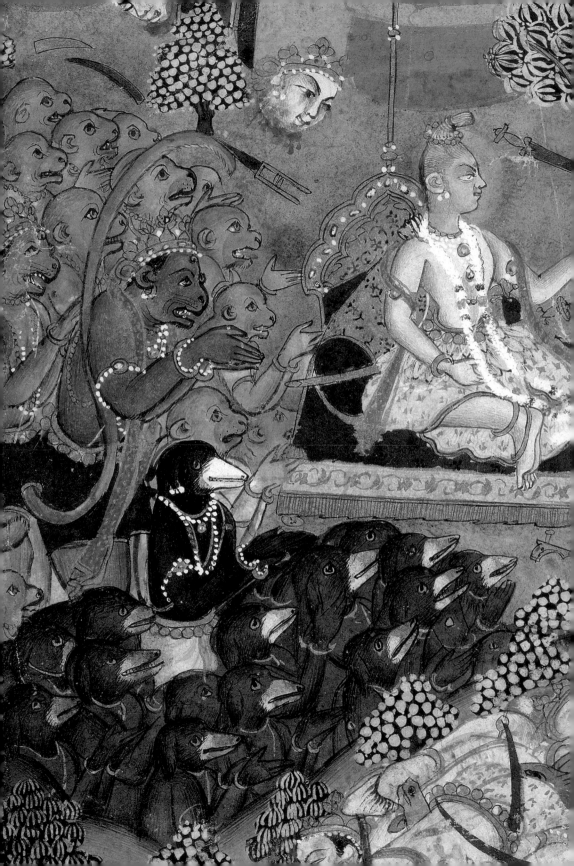

ACKNOWLEDGMENTS

Betty Seid and I are delighted to have had the opportunity to work on the little-known but substantial collection of Indian paintings in the Art Institute, to organize this exhibition, and to write the catalogue. We are both indebted to Director James N. Wood and Pritzker Curator of Asian Art Stephen Little for their enthusiasm and encouragement. In order to reach a wider public, we decided to select only those pictures that include animals, which often play an important role in India in myth and art. The component "Holy Cow" in the exhibition's title, an exclamatory form of the expression "sacred cow" and one of the many contributions to the English language of the Indian cultural matrix, reflects the enormous religious significance of animals in India. Considering that Chicago also is the city where the "Bulls" are venerated, the title seems particularly appropriate and reflects the fun we have had with the project.

Many individuals have helped us cheerfully in both organizing the exhibition and in preparing the catalogue. It is our pleasure to thank them all and, in particular, the following: for scholarly contribution, Dr. Catherine Glynn, Dr. Robert Dankoff, Dr. John Seyler, and Robert Skelton, OBE; for the publication, Lyn DelliQuadri, Nicole Eckenrode, Diana Fabian, Sarah Guernsey, Brockett Horne, Katie Reilly, Susan Rossen, and Catherine Steinmann; and, for the exhibition, Mary Albert, Susan Sayre Batton, Ryan Butterfield, Katherine Dugdale, Ryan Gregg, Deanna Lee, Craig McBride, Mary Jane Mullen, and Shilpa Sagar.

Pratapaditya Pal
Visiting Curator of Indian, Himalayan, and Southeast Asian Art

Detail of *Reunion of Rama and Sita*
(cat. no. 12)

INTRODUCTION

Pratapaditya Pal

All spiritual interests are supported by animal life.

—*George Santayana*

I.

The paintings and painted borders discussed in this exhibition catalogue were all rendered on the Indian subcontinent between the fifteenth and the early twentieth centuries. The majority belong to the Mughal and Rajput schools of painting, which flourished mostly in Panjab, Kashmir, the hill states (now in Himachal Pradesh), the Delhi region, and Rajasthan. Others are from Gujarat, in the west, and Orissa and Calcutta, in the east, and a few are from south India.

The term "Mughal" is generally applied to the Islamic dynasty that ruled much of northern India from the time of the third Mughal emperor Akbar (r. 1556–1605) to that of Aurangzeb (r. 1658–1707) and, thereafter, with continuously decreasing authority, until 1858, when the British Crown took over the administration of the country. Mughal authority was abolished, but local rulers, both Hindus and Muslims, continued to govern their own states under British sovereignty. Among these states, which were scattered all over the subcontinent, the most important for paintings was a cluster in Rajasthan and neighboring regions in the plains and the hill states of the British province of "Punjab." Few of these hill states survive today in the Panjab, which is divided between India and Pakistan. The majority are in India's Himachal Pradesh and adjoining areas of Jammu. Early in the twentieth century, Ananda K. Coomaraswamy introduced the designation "Rajput" to differentiate the paintings that emerged from the courts of the Hindu states, both in the plains and the hills, because the rulers called themselves Rajputs. There are significant stylistic differences and thematic variations within the Rajput school between the plains and the hills, the works of the latter known by the term "Pahari." Although the Mughal and Rajput schools share many features, their pictures do reflect different cultural traditions, religious beliefs, and aesthetic norms.

All of the works in the catalogue are executed on paper, with the exception of three that are painted on cloth. The three are also exceptional for their size and function. They are of monumental proportions, compared to which the works on paper seem puny. The relatively small size of most Indian paintings on paper of the Mughal-Rajput schools has resulted in their being characterized as "miniatures," a misnomer that originated and persists in Western scholarship. They are much larger than the true miniatures of the western tradition, or Jain manuscript illustrations, which are typically very small (see cat. nos. 5, 6, 7).

Many of the pictures were created to be included in albums, which were generally stored away in libraries *(pothikhana)* and were brought out occasionally for viewing; this accounts for their often pristine condition. They were never meant to be matted, framed,

PAGES 10–11: Detail of *Four Portraits in a Border with Flowers and Birds* (cat. no. 36)

INTRODUCTION

and displayed on walls, as they are in museums today. Rather, the viewer would sit along with fellow connoisseurs, hold each painting in hand, and savor it in a leisurely fashion.

The artists were almost always male, but female patrons were not unknown. Moreover, the artist's personal faith did not affect his ability to work for a patron of another religious persuasion. Signing a picture was uncommon; only a few in the collection bear the names of the artists who painted them. These artists were professionals who worked either for individual patrons or for courts, or were on their own, remaining in a town or moving from place to place in search of commissions. Their patrons included rulers, courtiers, religious establishments, and merchants, and, after the eighteenth century, European administrators and traders and perhaps even tourists.

The earliest paintings in the group (cat. nos. 5, 6, 7) are illustrated pages from Jain manuscripts of the fifteenth century that were commissioned by pious followers of the faith and given to monks for recitation during religious festivals. A similar function may have motivated the preparation of the solitary folio (cat. no. 8), with text on one side and a picture on the other, from a sixteenth-century manuscript of the *Bhagavatapurana*, a didactic Hindu religious text that is still read periodically in the homes of devout Vaishnavas (worshipers of Vishnu).

II.

The primary purpose of this book is not to provide a history of Indian painting through examples culled from the collection, but to emphasize the role of animals, both thematic and representational, in the pictures. Across the wide variety of narrative and literary traditions and genres represented in these pictures, it is remarkable how often animals are significant presences. In some instances, as in the genre known as *ragamala*, animals are not mere props in the composition, but just as necessary as the humans to express the flavor and mood of the subject, which is a poem describing a musical mode. And those who are familiar with Indian art will know that the gods of the Indian religions not only use animals as their "Rolls-Royces" to get around but are themselves often given forms with animal limbs. This latter custom, of course, was once common among many civilizations, especially of West Asia and Egypt, and also in Africa and the pre-European Americas. The Indic religions are the only ones that continue to represent and worship gods in the image of both man and animal. Some of these composite figures can be seen in the few pictures portraying gods in this selection.

The most familiar Indian deity is undoubtedly Ganesha, distinguished by his elephant head (see cat. nos. 1, 17). A native of the Indian subcontinent, the elephant possesses physical strength, power, and intelligence that must have become obvious to Indians early in their history, and from awe to worship required no big step. It was certainly the

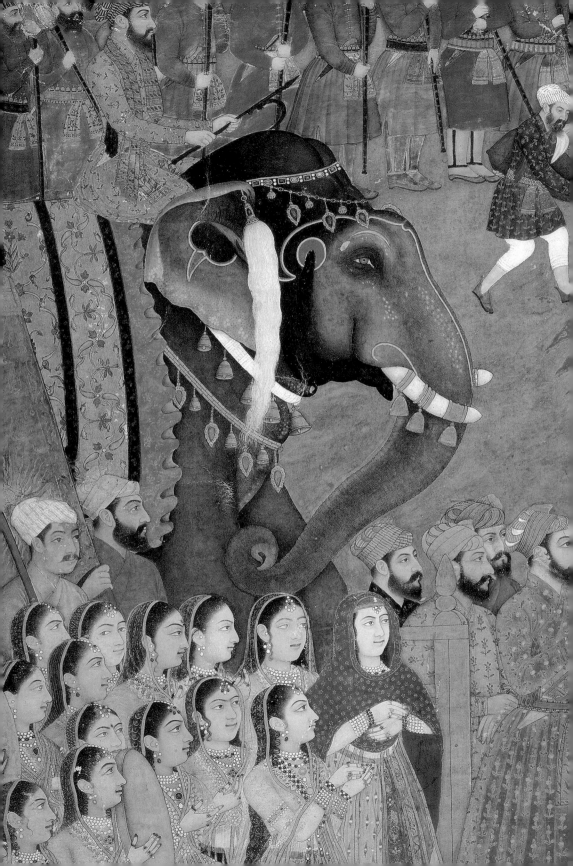

animal *par excellence* for royal pomp and pageantry, and hence was given to the chief of the gods, Indra, as his mount. The elephant was used by the Greek conqueror Alexander when he arrived on the subcontinent in 327 B.C., and Indian rulers of all shades and races, foreign or native, have employed the animal, particularly on ceremonial occasions. Few Mughal pictures portray the grandeur and elegance of an imperial procession with more graphic detail than that in the collection showing the Mughal emperor Shah Jahan (r. 1627–58), the builder of the Taj Mahal, entering his capital (cat. no. 19; see detail at left).

Ganesha is not the only deity who has an animal head. The Hindus believe that when the earth is overloaded with irreligiosity and wrongdoing *(adharma)* or disorder, Vishnu, the preserver of the universe, appears in a suitable guise, both human and animal, to restore cosmic and social stability. Of his nine major past incarnations, or avatars, he has appeared four times as animals—a fish, a tortoise, a boar, and a lion. His leonine form, known as Narasimha (see cat. no. 2), as well as his boar manifestation, known as Varaha, are generally shown, like Ganesha, with an animal head and a human body, a mode that was popular in ancient West Asia and Egypt. In two Jain paintings in the collection (cat. nos. 5, 6), we encounter a goat-headed deity who is sent to earth as a divine messenger to transplant an embryo. Admired for its sexual prowess, the goat was an appropriate symbol of a deity that facilitated birth.

Another species of domesticated animal that looms large on the Indian horizon is the bovine. The cow, the bull, and the buffalo are all associated with the gods in one form or another and accorded divine status. Like the elephant, the bull—especially the splendid animal that came to be known as the Brahman bull—is still much admired the world over for its genetic superiority in breeding cattle. In India the bull remains popular for agricultural and transportation purposes. Cattle in antiquity were the primary constituent of a person's wealth, as is clear from the Vedic texts composed around 1000 B.C. In Hindu mythology the bull became the mount of the god Shiva, who originally appeared as Rudra to protect and increase the community's cattle and was later known as Pashupati, or lord of all creatures. Krishna, another important god, was known as the divine cowherder. Because the cow provides milk to nourish both humans and the gods, whose preferred food is rice cooked in thickened and sweetened milk (the origin of western milk pudding), it came to be regarded as a surrogate mother. Thus, although beef was a desirable part of the diet of the people whose religious aspirations are reflected in Vedic literature, gradually an aversion developed toward eating the flesh of the animal, but all its other products, such as milk and even urine and feces, have remained acceptable as "blessings" *(prasad)* of mother cow. Indeed, so important are cattle in Hindu life and mythology that the cow, in the form of Kamadhenu, is the source of all that human beings desire (see cat. nos. 16, 17), and the bull is the animated form of the abstract concept of dharma, literally, "that which sustains."

Detail of *Illustration from the* Padshahnama
(cat. no. 19)

The bull and the elephant are two of the three auspicious animals that appear in the dream of Queen Trishala before she conceives Mahavira, the last of the twenty-four emancipated teachers of the Jains (see cat. no. 7). And, although not represented in the collection, the story of the Buddha's mother dreaming of an elephant before his birth is well known. The third beast that appears in Trishala's dream is the lion, which in Hindu mythology is also the mount of the goddess Durga. Even more so than the elephant, the lion remains the symbol *par excellence* of majesty and royal glory. The two popular motifs known as *kirtimukha* ("face of glory," in the form of a lion mask) and *gajasimha* (a lion trampling an elephant) are ubiquitously present on thrones used for both divinities and mortal rulers (see cat. no. 17). The Sanskrit word for throne is *simhasana*, or "lion throne," and the proverbial ability of the lion to kill the elephant is used in the *gajasimha* motif as an allegory of the king of men destroying his mighty enemies.

III.

Animals also are used frequently in the Indian narrative tradition, whether in legends and myths, tales with moral messages, or rhetorical literary genres. Hindu mythologies from such texts as the tenth book of the *Bhagavatapurana* (ninth century A.D.), or stories and episodes from the epics *Ramayana* and *Mahabharata* (based on oral traditions of the first millennium B.C.), continued to provide themes for Rajput patrons well into the nineteenth century. These legends and sagas invariably include animals, who often are essential characters in the narratives, and who always behave like humans. It is impossible to imagine a *Ramayana*, for instance, without the heroic figures of the monkeys, especially Hanuman, whose heroism is no less than that of the story's human hero, Rama (see cat. nos. 11, 12). And indeed, in most of the heroic episodes of Krishna's childhood, the antagonists are animals.

Some of these narratives involving animals we have already encountered in Section II. Among others, mention may be made of the sixteenth-century illustration of the battle between the armies of Krishna and Shiva in a folio from a manuscript of the *Bhagavatapurana* (cat. no. 8; see detail at right), an illustration of the folk tale based on the story of the father-and-son duel from the *Mahabharata* (cat. no. 9), and two monumental narrative scrolls from Orissa and Andhra Pradesh (cat. nos. 16, 17). Although the scrolls are from the nineteenth century, they represent an ancient Indian tradition of storytelling that can be traced back in literature to at least the fifth century B.C. Storytellers used horizontal and vertical scolls as illustrations for their tales, and the former were probably the source of the Chinese tradition of horizontal scroll painting.[1]

The Paithan picture (cat. no. 9) is clearly a continuation of the narrative mode of the earlier *Bhagavatapurana* picture (cat. no. 8), though no written text appears on the back and the composition is less crowded, with fewer episodes of the story accommodated

Detail of *Folio from a* Bhagavatapurana *Manuscript: A Raging Battle* (cat. no. 8)

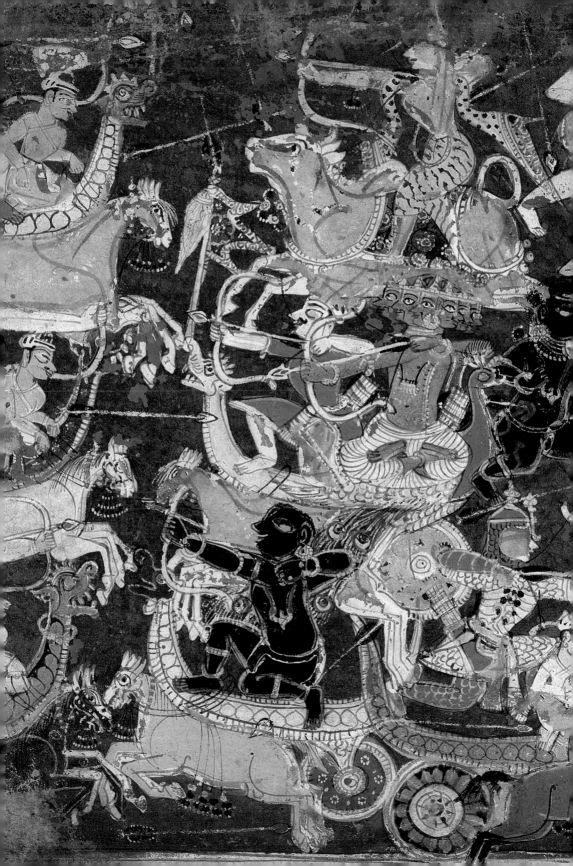

in the space. Moreover, unlike in the former picture, the animals here are represented with the same monumentality and clarity as the anthropomorphic characters.

It should also be noted that the emphasis generally is on flights of imagination, as one encounters in today's cartoons and animated films, rather than on accurate observation. While some animals, like the bovines and elephants, are represented with remarkable acuity, most creatures are conjured up from the artists' imaginations.

Tales and fables with beasts and with a moral message have always been popular in India. In the stories of the Buddha's former lives in the *jatakas* and *avadanas*, he is often born as an animal, and the collection of animal stories known as the *Panchatantra* enjoys enormous popularity globally, having been translated into more than fifty languages. Some of these tales may have had a common origin in the folk traditions of the Indo-Europeans, since similar tales are found earlier in Greek, in the structurally different Aesop's fables. One of these fables, concerning a greedy and foolish dog, is the subject of a fascinating picture in the collection (cat. no. 10; see detail at right). Rendered by the well-known Mughal artist Farrukh Chela toward the end of the sixteenth century, it is a fine example of the more naturalistic and painterly Mughal style, which differs notably from the Rajput style. Rich in pictorial devices that allude to the lesson on covetousness, the representation is more realistic in its use of space and architecture than is the typical Rajput painting, but more imaginative in the portrayal of the animal and in the eerie mood conveyed by tonal variations.

A narrative genre that is wholly Indian and that was extremely popular with patrons of Indian painting from the seventeenth century onward is known as *ragamala*, literally, "garland of melody." *Ragamala* paintings illustrate six basic musical modes known as *raga*, and thirty or more derivatives designated as *ragini*. A *raga* is a male mode while *ragini* is a female. Poets composed short verses, often included above the pictures, about these modes. These verses provide a word picture of a romantic situation or a devotional sentiment that was given visual expression by the artist. Often animals are included in these paintings as companions of the personified *raga* or *ragini*, as an empathetic audience, or as symbols, visual metaphors, or allegories. The three examples selected here are representations of the *raginis* known as Kakubha, Todi, and Bangal.

In the first example (cat. no. 13), Kakubha walks with two garlands in her hands as she roams the forest in search of her lover, around whose neck they will be hung as a token of her commitment. The garlands are symbols of union for a Hindu wedding, which is sealed by their exchange between the groom and the bride. Usually a solitary peacock listens to her soulful melodies, but here the artist included six of them, forming a semicircle and showing off their charms like eager suitors.

Detail of *Aesop's Fable of the Greedy Dog,
from the* Anwar-i-Suhayli (cat. no. 10)

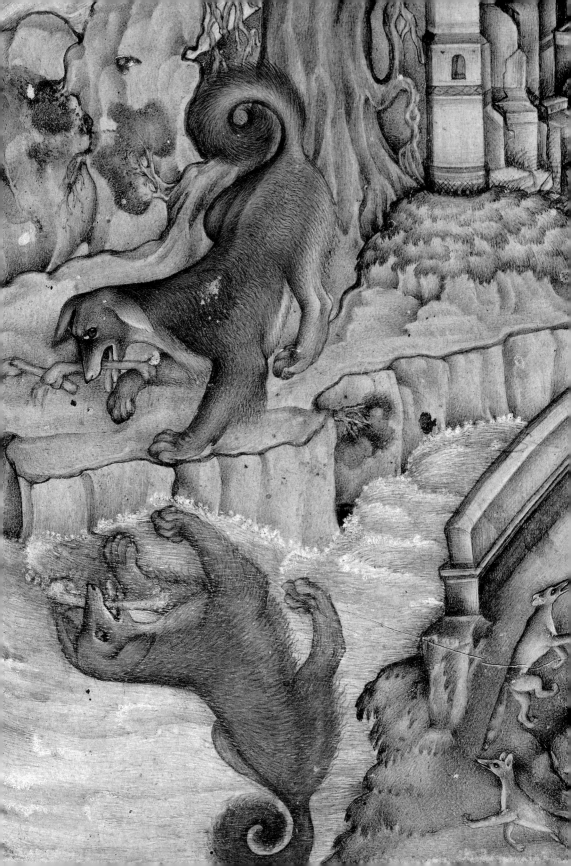

More intriguing is the iconography of the second picture (cat. no. 14), which depicts a tête-à-tête between a young woman and a tiger on a carpeted terrace beside a lotus pool. The beast of prey seems transfixed by the lady's song, which she performs to the accompaniment of a sarod-player. Usually the Bangal *ragini* is portrayed as an ascetic with a trident, but here she is clearly a noble lady, possibly even a rich courtesan. The tiger is also closely associated with Bengal, the name of which is an anglicized version of Bangal, or Vangal. Thus, Bangal is clearly a mode associated with the region in eastern India known once as Bengal and now as West Bengal (India) and Bangladesh. (Incidentally, the word "bungalow" is also derived from Bengal, and the Cincinnati Bengals take their name from Bengal tigers.)

The straightforward text accompanying the image of Todi (cat. no. 15) describes her as a forlorn lady who charms the wild deer with the sounds of her vina. Three of these animals listen as she plays and sings the melancholy tale of her loneliness. The unknown Sirohi artist has added a peacock as well, however, perhaps as a symbol of the absent lover.

As may be seen in all three representations, scale and realistic proportions are of little concern. While the deer and the peacocks are convincing visualizations, the tiger is a conceptual representation with gray neck and chest (anticipating a mixed breed of today called a "tigon").

IV.

Most of us have been brought up in mechanized societies where our daily contact with animals is minimal, unless we have house pets, which in urban areas are generally limited to dogs and cats. Only those who live on farms have direct experience with a greater variety of animals, although there, too, many of the tasks that once were performed in a symbiotic relationship between man and beast are conducted with machines. Rare is the farmer who milks his cow or goat with his hands or uses a horse to turn his field before sowing. These experiences are still available only in the developing world, although there, too, the tractor is replacing the horse, the ox, and the buffalo. On dairy farms mechanized rubber suction cups are replacing the human hands once used for milking, and, in the forests and battlefields, the forklifts and tanks are taking over the role of the versatile elephant.

The painted world of the Mughals and Rajputs preserves for us extraordinary vivid images of daily encounters, some pleasant and others less so, between humans and animals. The Europeans' love for cats and dogs is graphically and empathetically portrayed in a meticulously observed, tinted drawing of a banquet scene by an unknown Mughal artist (cat. no. 18). In contrast to this picture, which is enlivened by a social conviviality and festive spirit, is a more colorful but doleful image from the Rajput state of Bundi (cat. no. 25) in which we, along with a princely voyeur behind the banana trees, can spy on a lady biding her time with her maid and a school of fish eager for their daily rations.

Animals were, of course, the principal mode of transportation for the rich and powerful. The elephant and the horse were the two favorites, as we see in two beautiful pictures. The earlier of the two, from the *Padshahnama*, an album prepared for Shah Jahan to record his imperial rule, is a detailed and acutely observed rendering of an imperial procession that conveys all the pomp and pageantry of such occasions (cat. no. 19). While the caparisoned elephant reveals the traditional confidence of Indian artists in representing the pachyderm, the more naturalistic depiction of the horse in Indian art is a contribution of the Mughals. In the Indian way of thinking, however, the horse bearing royalty was not just another animal to be observed and drawn accurately. It could not match the elephant for size in life, but in art its form could be manipulated to convey the majesty of the ruler. So in a magnificent Mewar picture (cat. no. 22; see detail on following page), the horse's splendidly embellished form reiterates the importance of his royal, and, indeed, divinized rider.

Another creature that was—and still is—a popular mode of transportation in India is the camel, which appears in two paintings in the collection, though in strange ways. In one (cat. no. 37) he does serve as a conveyance, but of a supernatural being known as a peri. His form is an imaginative and deft Arcimboldesque conglomeration of man and beasts, like a crowded hull of Noah's ark. In a second picture (cat. no. 26), a hapless camel, though a large beast, is mercilessly crushed by an elephant, leaving no doubt as to who is physically the stronger.

Finally, an Akbar-period Mughal picture shows a young prince, perhaps the young ruler himself, riding through the country on the outskirts of a city in a cart drawn by a pair of billy goats (cat. no. 21). As early as the second century in the art of Gandhara, one sees the young Buddha Shakyamuni riding to school in a cart drawn by rams.[2] It appears both animals were preferred as transport for young boys, as were the smaller Shetland ponies in Europe.

Animals have played an important role in entertaining the elite, as they still do for a more diverse audience in the circus. One of the curious ironies of "civilized" life is man's use of animals to hunt other beasts for pleasure. The most persistent example of this peculiar tradition is the fox hunt in the United Kingdom and America. In India one not only rode horses (see cat. no. 24) and elephants for hunting, but had two other favorite hunting companions, the trained cheetah (now extinct on the subcontinent) and the falcon. Familiar from ancient times in Asia and the Roman empire, the use of both was popularized in India by the Mughals. In the Mewar picture, we see Maharana Bhim Singh, a Hindu prince, setting off on a hunt with a cheetah (cat. no. 22), while in a splendid portrait of the Mughal prince Azam Shah (cat. no. 23), painted in the third quarter of the seventeenth century, the artist chose to represent him as a keen falconer. Sometimes an unexpected bonus during a hunt was a visit to a holy man who lived in the forest. One Shah Jahani picture in the collection, probably painted in

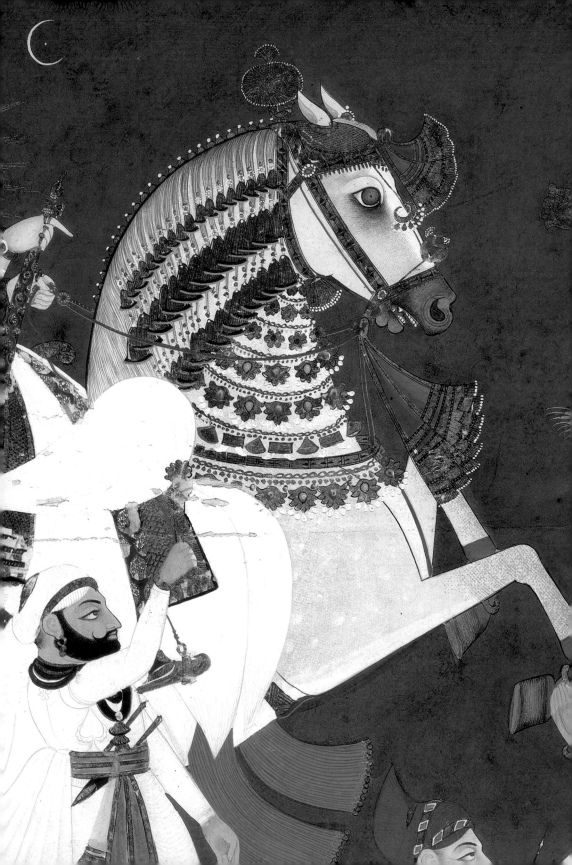

Kashmir, portrays such a visit (cat. no. 20). These pictures were particularly popular with the Mughals, as the earthly hunt in Islamic cultures is a metaphor of the search for the divine.

Quintessentially Indian entertainment was, however, the elephant fight, the elite version of the more proletarian cockfight. Though only the ruling class could stage it, the spectacle was enjoyed by the public as well. It was a bloody event. In the words of an eyewitness, the French physician François Bernier, who visited India between 1566 and 1568,

> A wall of earth is raised three or four feet wide and five or six feet high. Two ponderous beasts meet one another face to face, on opposite sides of the wall, each having a couple of riders. . . . The riders animate the elephants by soothing words, or by chiding them as cowards, and urge them on with their heels, until the poor creatures approach the wall and are brought to the attack. The shock is tremendous, and it appears surprising that they survive the dreadful wounds and blows inflicted with their teeth, their heads, and their trunks.[3]

An eighteenth-century drawing in the collection (cat. no. 27) is a lively rendering of such a fight. It is from the Rajput state of Kotah, which seems to have continued the tradition with great zeal when Mughal power was on the decline, for the largest number of representations of the elephant fight have survived in that state. Also from Kotah, though not depicting an "entertaining" event, is another drawing in the collection (cat. no. 28), recording a particular elephant, called Gajanandana, gone berserk *(must)*, as bull elephants do when in rut. While staged duels between two elephants were dangerous mostly for the animals themselves, an elephant in Gajanandana's state could have fatal consequences for humans.

V.

The portrait of Gajanandana introduces another mode of animal representation that began with the Mughals. Not only did they encourage their artists to depict their animals with greater observation and veracity, as is clear from a comparison of animals in pre-Mughal Indian art and those produced under Mughal patronage, but they also introduced the practice of portraying particular animals. This tradition was begun by Emperor Jahangir (r. 1605–27), who inherited his avid interest in natural history from his great-grandfather Babur (r. 1526–30), the founder of the Mughal dynasty. Stories about Jahangir's interest in and collection of exotic animals and the portraits he had painted of them are numerous and legendary. Some of these, such as the zebra by Mansur, perhaps the greatest animal painter the subcontinent has ever produced, and the

Detail of *Maharana Bhim Singh*
(cat. no. 22)

squirrels by Abul Hassan, another favorite artist of Jahangir's atelier and much admired for his virtuosity with the brush, have acquired iconic status in the history of Indian painting.

While the collection contains no works by either of these geniuses, there are a number of perceptive and accurate animal studies that are interesting from both the artistic and the scientific points of view. It should be noted that, apart from studies of specific birds and animals, Mughal patronage was also responsible for introducing another type of animal drawing into India that continued the Persian custom of enlivening the borders of the mounts surrounding a picture or a choice specimen of calligraphy to be included in an album. These delightful borders often contain studies of animals, birds, and insects, as well as vegetal forms rendered with extraordinary powers of observation and visual acuity, as may be seen in the few examples included here (cat. nos. 34–36, 38).

Two Mughal album leaves enclose within floral borders representations of a shaggy, white Himalayan goat (cat. no. 34) and a rare, shy bird (cat. no. 29). Whether or not they were rendered for Jahangir's painted menagerie, they are good examples of the kinds of depictions of individual beasts that he initiated and that continued to be copied as late as the nineteenth century for later patrons who did not mind collecting imitations of works by the "old masters." Rajput patrons, too, began having portraits of their favorite animals, especially the horse, the elephant, and the hunting dog, rendered by their court artists. We have already alluded to the picture of the elephant Gajanandana, of the Kotah royal stable. Another is the calmer and sensitive portrait of a Rampur hound by an unknown master of the Mewar court (cat. no. 30). This picture reveals the influx of new representational ideas from yet another external source, this time Europe.

European pictures and prints were already familiar to Indian artists in Mughal court circles during the reign of Akbar. Both Akbar and Jahangir were admirers of these new curiosities and encouraged their artists to copy them both as academic exercises for improving their technical skills and as demonstrations of their talent and versatility. Indeed, Mughal naturalism would not have been possible without their artists' familiarity with and the patrons' interest in works of European origin.

A second dose of European influence was infused into the Indian artistic bloodstream in the second half of the eighteenth century with the appearance of European patrons, collectors, and artists. With the gradual expansion of European settlements, artists from Europe arrived to seek their fortunes, while European pictures were imported to decorate their homes. Many resident Europeans collected and formed Indian-style albums of Indian and Persian pictures and calligraphic exercises, which now form the nucleus of many well-known public collections in Europe.[4] The Art Institute has several pages from dispersed albums, including the *Padshahnama* and the Leningrad Album. Others were keen orientalists and commissioned original works of naturalist and ethnographic interest, which provided new patronage to local artists. Loosely, these pictures of diverse regional styles are lumped together under the rubric "Company School," since many of the

British patrons worked for the East India Company, which, after Robert Clive's "acquisition" of Bengal following the Battle of Plassey in 1757, became an increasingly powerful commercial and political force on the subcontinent. As the American colonies cut the umbilical cord with Britain, the British became even more entrenched in India.

Three animal pictures from the colonial period of Indian history are included here. One is a straightforward and highly observant study of a Grey Heron done between 1780 and 1820 in Calcutta (now Kolkata), then the seat of British authority on the subcontinent (cat. no. 31). The other two, painted about a century later, though in Tanjore (now Thanjavur), in the south, depict a performing bear and a baboon (cat. nos. 32, 33). While the heron is rendered with the accuracy that was the hallmark of contemporary or earlier natural history pictures in the West, the Tanjore pictures are more conceptually rendered, but with the whimsy and affection that have always been characteristic of the Indian tradition of animal drawing.

Even a cursory glance at the small group of paintings described and discussed in this publication will reveal the enormous diversity of their contents, both descriptive and narrative, and of their literary and mythological allusions, as well as the richness of their iconographical and formal elements. These are only touched upon here; nevertheless, the reader should be able to savor the flavor *(rasa)* of the intensely colorful and meticulously detailed pictures that expressively combine the earthly and mythical realms, involving both man and animals, with empathy and a sense of wonder.

Notes

1. See Mair 1988.
2. Pal 1984, no. 31.
3. Quoted in Pal 1981, p. 54.
4. See Harris 2001.

PAGES 26–27: Detail of *Dancing in a Palace* (cat. no. 35)

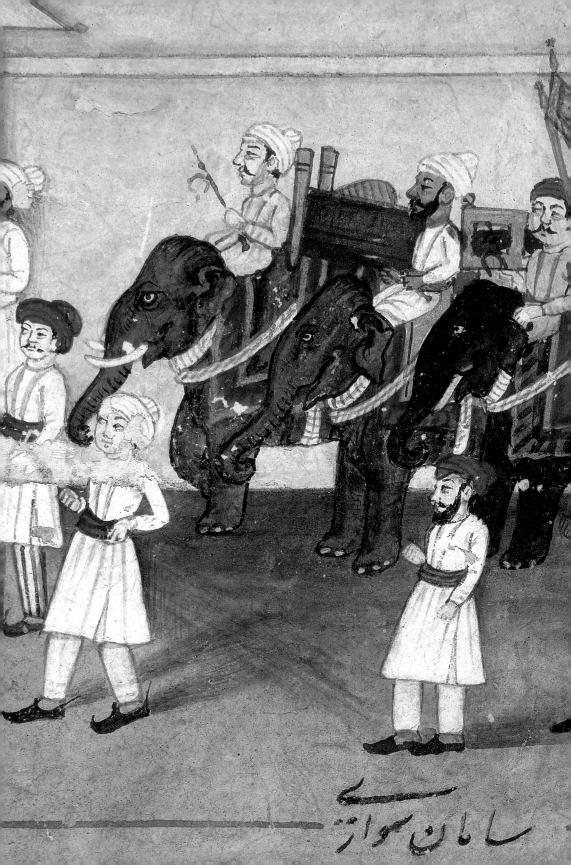

سامان سوار

CATALOGUE

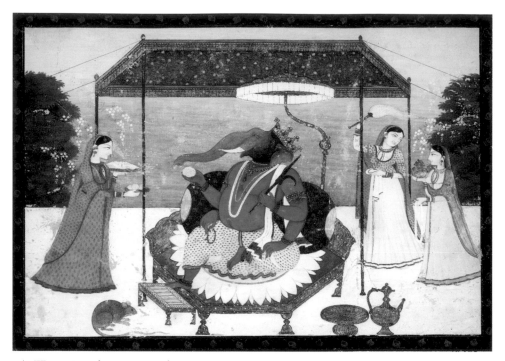

1 | *Women Worshipping Ganesha*

Himachal Pradesh, Kangra, Pahari, c. 1800
Opaque watercolor and gold on paper; 20.6 x 29.6 cm
Gift of Mr. and Mrs. James W. Alsdorf, 1968.690

The enthroned figure is the popular Hindu god Ganesha. Combining the human form with that of an elephant, whose admirable qualities include height, strength, docility, dexterity, intelligence, and longevity, Ganesha is one of the most popular of all Hindu deities. Here, shaded from the searing heat of the sun by both an umbrella and an embroidered canopy, he is bedecked with jewelry and an elaborate crown. His vehicle, the rat, waits patiently as female attendants fan him with a chowrie (fly whisk) and offer the sweets that sustain his "prosperous" belly. Although he is usually portrayed as chubby and childlike, here he has a regal demeanor. Ganesha is worshipped as both creator and destroyer of obstacles, which may reflect the complex nature of his father, Shiva, the cosmic Creator and Destroyer. But his duality might just as well have derived from the elephant, a creature at once destructive and serviceable, clumsy and monumental, fearsome and benign.

B. S.

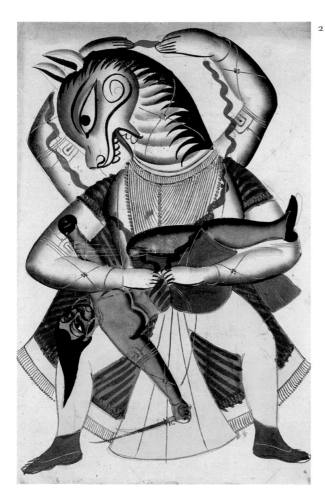

2 | *Narasimha, the Man-lion
Avatar of Vishnu*

West Bengal, Calcutta,
Kalighat, c.1875
Watercolor and silver paint
on paper; 43.5 x 28.2 cm
Gift of Mrs. Sara Raymond
Fitzwilliams, 1917.427

Assuming the composite form of a man-lion, Vishnu appeared on earth when King Hiranyakashipu challenged his son's faith in the god's powers. When the prince insisted that the omnipresent Vishnu might even inhabit the palace, the king, in an effort to disprove him, kicked a column. It split asunder, and the enraged god emerged as Narasimha, the man-lion avatar of Vishnu. He placed Hiranyakashipu on his lap and killed him by ripping open his belly and disemboweling him. While composite animals are commonplace in Indian visual culture, the graphic violence that dominates this image is unnerving.

This bold image of Narasimha is characteristic of the Kalighat school of paintings in Calcutta. Rapidly executed with broad strokes on thin, machine-made paper, the sheet originated as an inexpensive memento of a visit to a holy site. When installed in a domestic setting, it provided a means to extend the pilgrimage experience.

B. S.

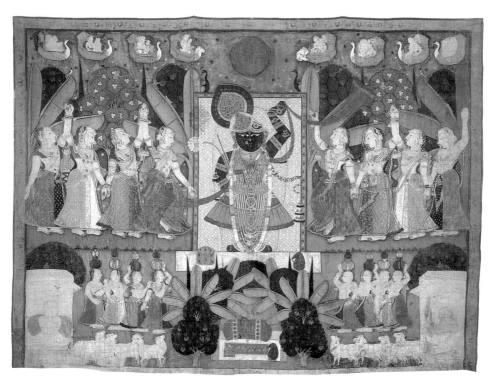

3 | *Adoration of Krishna as Shrinathji*

Rajasthan, Nathdwara, c. 1850
Opaque watercolor on cotton; 260 x 325 cm
Robert C. Ross Foundation Endowment, 1996.87

This large painting is of a type known as *pichhvai*, which is used on festive occasions as a backdrop for a statue of Shrinathji, a representation of the god Krishna that is the primary cult image of the Vallabhacharya sect of Hinduism. In this simplified, abstracted representation, Shrinathji assumes the stance of the adolescent Krishna, lifting Mount Govardhana with his left hand to shelter his cowherder companions and the cows from a storm.

This *pichhvai* was used on the full moon in autumn, when Shrinathji performs a circular dance *(rasamandala)* with the cowherdesses *(gopi)*. Among the animals that enliven the scene, the most important are the cows, who gaze adoringly at their master. The gods above ride aerial cars, whose fronts show their animal mounts. The two leaders of the gods, Shiva, with his bull, and Indra, with his elephant, are on either side of the silver moon. Two peacocks are perched near the top of the backdrop; the bird also provides the deity with its beautiful feathers to form the plume that adorns his head. With its vibrant colors, the painting joyously conveys the gaiety of the occasion.

P. P.

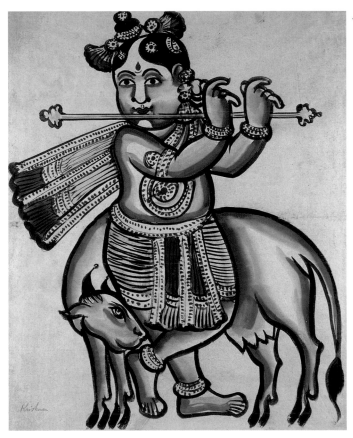

4 | *Krishna with a Cow*

Tamil Nadu, Tanjore, c. 1910
Watercolor on paper;
42 x 34.3 cm
Gift of Mrs. Carolyn Wicker,
1939.346

The intimacy between the animal and the child-god Krishna is clear in this simple and graphic composition. Standing behind him, the cow turns her head to lick the heel of Krishna's right foot. Krishna is a chubby boy; this is not surprising considering his passion for milk products of all kinds, which is also reflected in his endearing sobriquet Makhkhan-chor, or "butter-thief." Cows have contributed to two of Krishna's other popular names: Govinda, or lord of the cows, and Gopala, or cowherder. Though portrayed as a child, he strikes the classic posture of the adolescent Krishna, who charms both the animals and cowherdesses *(gopi)* with the melodious sound of his bamboo flute, much like Orpheus in classical Greek mythology. The artist used the same rosy complexion for both man and beast in this painting, thereby emphasizing their symbiotic relationship.

P. P.

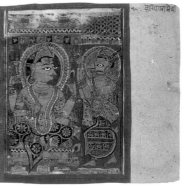

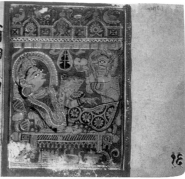

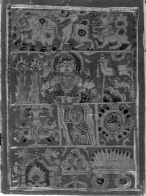

Three Folios from Kalpasutra *Manuscripts*

Gujarat, 1475/1500

Opaque watercolor, gold, and ink on paper

5 | *Indra and Harinaigamesha*

11.2 x 29.5 cm

Everett and Ann McNear Collection, 1982.1309

6 | *Transfer of Embryo*

11.1 x 29.9 cm

Gift of Mr. and Mrs. Harry Lovi, 1976.153

7 | *Queen Trishala's Dreams*

11.2 x 26 cm

Everett and Ann McNear Collection, 1982.1312

These three illustrated folios are from manuscripts of the *Kalpasutra*, a canonical text of Jainism, the third religion that originated in the Indian subcontinent. The text was frequently copied and illustrated, especially after paper was introduced by the Muslims in the fourteenth century, and particularly in Gujarat. The format, as well as the mode of writing, however, continued the traditions that had been established when the illustrations were made on palm leaves. Usually, the text consists of seven to nine lines, as well as commentaries in smaller letters. The illustration is accommodated at one end of the page in a rectangular composition. Since the *Kalpasutra* contains conventional hagiographies of the twenty-four liberated saints of the Jains, the images have a narrative content. Generally, only the lives of the four popular Jains are described at length, the most important being Mahavira, the last saint to be liberated. A historical figure, he was an elder contemporary of the Buddha; both lived in the sixth and fifth centuries B.C.

The three scenes represented here describe episodes from the birth cycle of Mahavira. In all three, animals play important roles. In the first (cat. no. 5), Indra, the king of the gods, instructs Harinaigamesha, the goat-headed celestial in charge of fertility matters, to go to earth and transfer the embryo from the womb of a brahman woman to Queen Trishala, of the kshatriya (warrior) caste, for Mahavira was destined to be born into a kshatriya family. In the second (cat. no. 6), Harinaigamesha has completed the transfer and reverentially awaits the safe delivery of the infant. The third (cat. no. 7) depicts the fourteen auspicious symbols that appear in dreams to Trishala before she gives birth to the saint. Significantly, three of these are animals, represented in the top register: elephant, bull, and lion, the last of which is now represented as a composite leonine creature with a blue trunk raised like a trumpet.

The compositions in these illustrations are made up mostly of two or three figures that dominate the space and appear larger than life. The palette is limited to red, blue, black, white, and gold, all deftly manipulated and layered to impart a sense of volume. A distinguishing feature of this style of painting is the complete depiction of both eyes in the profile representation of the head, a mannerism that four centuries later would be used effectively by Pablo Picasso (1881–1973).

P. P.

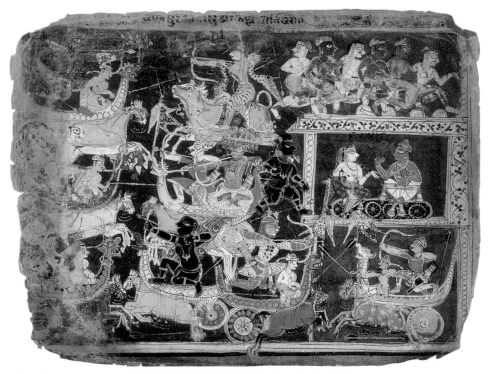

8 | *Folio from a* Bhagavatapurana *Manuscript: A Raging Battle*

Northern India, 1525/50
Opaque watercolor on paper; 18 x 23.5 cm
Gift of the Joseph and Helen Regenstein Foundation, 1962.641

This folio is from a manuscript of the *Bhagavatapurana*, which is one of the most popular religious texts of the Vaishnavas because it includes the story of Krishna, an avatar of Vishnu, the god to whom Vaishnavas are devoted.

The raging battle depicted here is one between Krishna and Shiva that followed the discovery of the clandestine affair between Usha and Aniruddha. Usha was the daughter of the titan Bana, an ardent devotee of Shiva, while Aniruddha was Krishna's grandson.

Thus, this legend encapsulates the rivalry between the followers of Shiva and Vishnu.

At the upper left, Krishna faces the tiger-skin-clad Shiva on his bull. Immediately below, Balarama, Krishna's half-brother, engages the multiheaded Bana, further identified by the peacock on which he sits. Except for Shiva, all the figures ride on chariots shaped like dragon boats and drawn by different-colored horses. At the right, the lovers Usha and Aniruddha sit in a pavilion.

P. P.

ANIMALS IN NARRATIVES

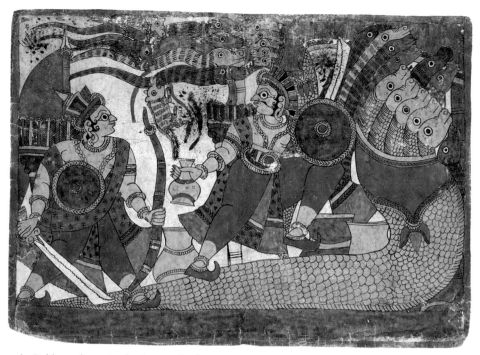

9 | *Babhruvahana in the Serpent Realm*

Maharashtra, Paithan, c. 1800
Opaque watercolor (and betel juice?) on paper; 30 x 42 cm
RX 20766/526

This dynamic composition, with its bold figures and strong colors, shows Babhruvahana in the netherworld, the habitat of serpents, or *naga*, in Indian cosmology. Babhruvahana is a son of Arjuna, one of the Pandava brothers, the protagonists of the *Mahabharata*, the great saga of the war among the cousins of the Bharata clan. In one of the stories from this epic, Babhruvahana unwittingly kills his father during a quarrel. Babhruvahana's stepmother, Ulupi, a princess of the Naga realm, dispatches him there to fetch a miracle gem that will revive his father.

This painting illustrates an embroidered, oral version of the story, in which the blood of reptiles, rather than the gem, is used to revivify Arjuna. Babhruvahana stands on a giant serpent, holding a jar to collect blood streaming from other snakes wounded by three ferocious mongooses *(babhru)*. The mongoose is the young hero's vehicle *(vahana)*, from which his name derives. The second figure, with sword and bow, may represent Arjuna after his recovery.

This picture is one of a series made to illustrate "The Sons of Arjuna," the principal characters of which are from the *Mahabharata*; this tale formed part of the repertoire of itinerant storytelling artists of the *chitrakathi* caste in Maharashtra and neighboring Andhra Pradesh.

P. P.

Aesop's Fable of the Greedy Dog, from the Anwar-i-Suhayli

Farrukh Chela (active 1580–1604)
Mughal, late sixteenth century
Opaque watercolor and gold on paper; 33.4 x 20.8 cm
Lucy Maud Buckingham Collection, 1919.951

In art and literature, animal behavior often acts as an allegorical mirror of human activity. This painting illustrates a well-known fable by Aesop about a dog on its way home with a prized morsel in its mouth. The dog spies in a pool of water what appears to be another canine carrying an equally delectable treat that it decides it must have as well. The second dog stands perfectly still, returning the first one's gaze until, with the snapping of a jaw, the mouthfuls—both real and reflected—are lost forever in the water's depths. The famous ancient Greek writer's witty moral tale illustrates succinctly the lesson that, in coveting, one can risk losing everything.

Ironically, Aesop was killed in an incident involving covetousness. Born into slavery around 620 B.C., he was freed by his second master as a reward for his wit and erudition. He thereafter traveled widely, instructing and entertaining with his fables. He eventually found himself in the court of the wealthy king Croesus, who sent him to Delphi to disburse a large sum of gold among its citizens. Aesop was so incensed by their greed that he refused to distribute the gold, sending it back to Croesus. The outraged Delphians, ignoring Aesop's diplomatic immunity, executed him as a common criminal.

The artist, Farrukh Chela, is known for his depictions of idiosyncratic architecture: here, the cracks in the buildings may have been intended to elaborate upon the lesson by suggesting the encroachment of human ambitions on natural surroundings.

It is not surprising that illustrations such as this of Aesop's fables were executed during the reign of Mughal emperor Akbar (r. 1556–1605), who was extremely interested in teachings and cultures far beyond the reaches of his land.

B. S.

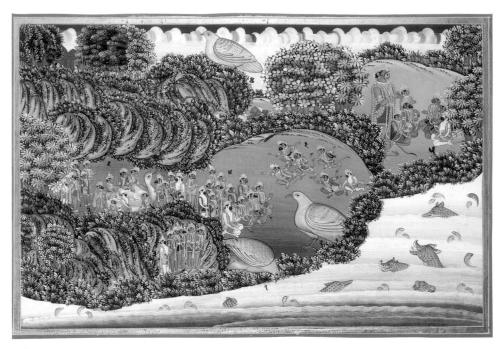

Two Illustrations from the Ramayana

11 *Hanuman Assembling His Army for the Crossing to Lanka*
Rajasthan, Jaipur, 1830/40
Opaque watercolor and ink on paper; 36.5 x 50.1 cm
RX 20766/518

12 *Reunion of Rama and Sita* (opposite)
Rajasthan, Datia, c. 1770
Opaque watercolor and gold on paper; 28.2 x 20.4 cm
Everett and Ann McNear Collection, 1980.337

Human dependence on the protection and service provided by animals is echoed in the great Hindu epic *Ramayana*, where they play a critical role. These images illustrate sequential episodes from the end of the tale, when the monkey general Hanuman, with unflinching devotion to the deity Rama, leads his legions to rescue Rama's wife, Sita, from years of captivity. Hanuman's fierce loyalty to his lord exemplifies *bhakti* (unconditional love of God).

Huge birds dominate the first painting (cat. no. 11), in which Hanuman gathers his troops to fly to the island of Lanka, where Sita is being held captive by the demon king Ravana. Other

ANIMALS IN NARRATIVES

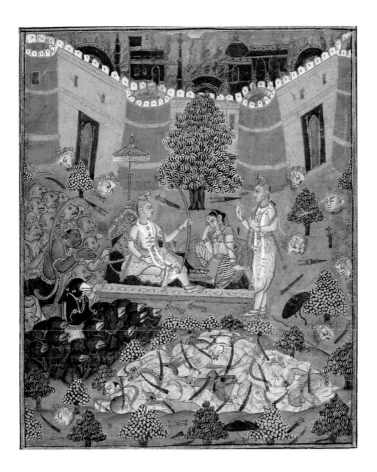

creatures enhance the scene: jungle animals populate the background foliage and fantastic sea creatures sport among the waves in the foreground. The birds' leader, Sampati, is the elder brother of Jatayu, a vulture that died trying to rescue Sita from Ravana's chariot at the time of her abduction. The second painting (cat. no. 12) illustrates a scene that takes place after Rama has rescued Sita. Hanuman has used his long, flaming tail to set Lanka on fire; it burns in the background. The reunited couple celebrates, along with Rama's brother Lakshmana, outside Ravana's burning palace. Dismembered soldiers from the defeated army are piled in the foreground, and disembodied heads dot the landscape.

Hanuman Langur, a primate species indigenous to the Himalayas and the Indian subcontinent, undoubtedly derives its name from the heroic simian in the *Ramayana*. Its long tail (*langur* means "long tail") and powerful hands and feet allow it to travel very fast and to leap great distances. Sacred to Indian Hindus, this monkey often accompanies holy men on their travels.

B. S.

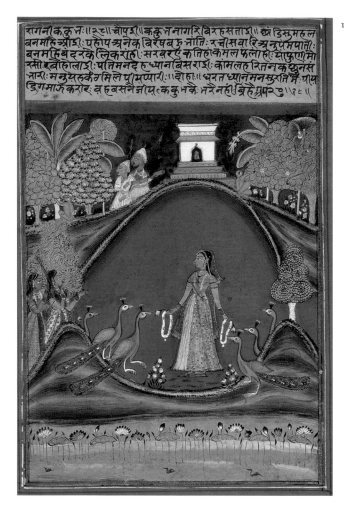

13 | *Ragini Kakubha*

Rajasthan, Jaipur, late
eighteenth century
Opaque watercolor and gold
on paper; 30.4 x 22.5 cm
Restricted gift of Russell Tyson,
1962.147.28

The peacock struts and preens as keeper of a harem of hens that he wins through showy courtship rituals: brutal combat with other males and an elaborate, passionate fan dance performed to impress his "intended." The peacock's jewel-like feathers often adorn the crown of the Hindu god Krishna, also renowned for his amorous activities. It is fitting, then, that the bird should symbolize the absent lover in this "morning-after" painting. Ragini Kakubha, the female personification of a pre-dawn musical mode, conveys a mood of loneliness and longing. Architecture, fruit-laden trees, capricious monkeys, male guards, and female attendants are all positioned outside the circle of her solitude. Her arms open in an empty embrace for her lover, who has just departed. Sadly, this young woman dangles garlands and lotus flowers, oblivious of the luxuriantly plumed males who seek her company.

B. S.

ANIMALS IN NARRATIVES

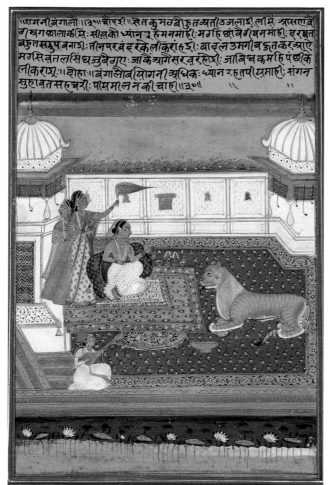

१४ | *Ragini Bangal*

Rajasthan, Jaipur, late
eighteenth century
Opaque watercolor and gold
on paper; 30.4 x 22.5 cm
Restricted gift of Russell
Tyson, 1962.147.30

A subdued—even kittenish—tiger, sitting on the floor opposite its elegant owner, is an unsettling element in an otherwise serene portrayal of pleasure. This painting represents the musical mode Ragini Bangal. Bangal is the Indian name of the eastern Indian region known in English as Bengal, which is home to the Bengal tiger. This majestic animal—now an endangered species—can be as large as ten feet long, weighing from four hundred to five hundred seventy-five pounds, with a shoulder span of three feet. Therefore, the relative smallness of the tiger in this image does not depict its true nature but rather symbolizes the cat's submission to its mistress. The Bengal tiger is a solitary, nocturnal animal whose mating season is in the spring: thus the appropriateness of a springtime musical mode performed before dawn.

B. S.

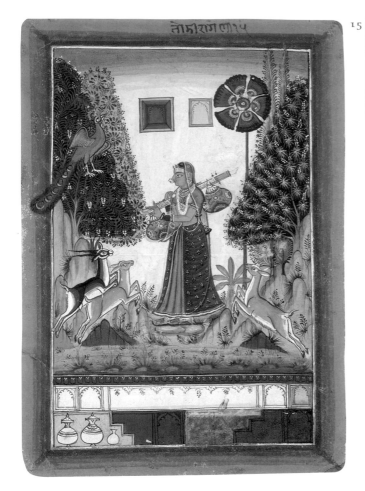

15 *Ragini Todi*

Rajasthan, Sirohi(?), c. 1675
Opaque watercolor on
paper; 22 x 15.5 cm
Gift of the Joseph and Helen
Regenstein Foundation,
1961.121

Deep in the forest, a black buck and his fawn-colored mate are the only audience for the feminine personification of the late-morning musical mode called Ragini Todi. The antelopes are drawn to the plaintive notes being played by the lovely young woman on her vina (a long-necked lute with two gourds as sound boxes). She sings adoringly about a lost lover, symbolically present in the form of a peacock, which appears aloof and uninterested. While the song's message is universal, its original purpose was specific: according to legend, it derives from a song of village girls guarding planted fields and ripening trees. Their seductive melody was believed to distract antelopes from feeding on crops. Even today, these vegetarian creatures—protected as an endangered species—impinge on the boundaries of farms and are a nuisance for farmers.

B. S.

ANIMALS IN NARRATIVES

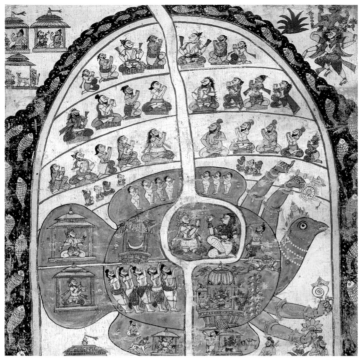

16 | *A Vaishnava Cosmological Scroll* (detail)

Orissa, c. 1850
Pigment on cotton; 550 x 70 cm
Gift of Mr. and Mrs. Robert O. Delaney Fund;
Margrette Dornbusch, Frederick and Natalie Gookin,
and Samuel M. Nickerson endowments, 2000.487

The telling of stories with pictures is a tradition on the Indian subcontinent that can be traced back to at least the fifth century B.C. Itinerant storytellers went from village to town and court to court recounting epic stories, religious myths, and imaginative tales of the afterlife with the aid of painted scrolls, both vertical and horizontal.

It is impossible to do justice in a brief catalogue entry to this rich, busy, and colorful painted scroll depicting Vaishnava cosmological themes. A rare monumental example of an Orissan painting on cloth, this may well be the only known example of a vertical scroll from that region of a type that was extremely popular in neighboring Andhra Pradesh (see cat. no. 17), with which Orissa has always had close political and cultural ties. This example has a more fluid composition than the Andhra scroll, however, and is not as rigidly divided into horizontal registers. The figural types, decorative motifs and ornament, and modes of drawing and coloring are quite different in the two traditions.

Unlike the Andhra work, this scroll has side borders (see detail above) filled with fish

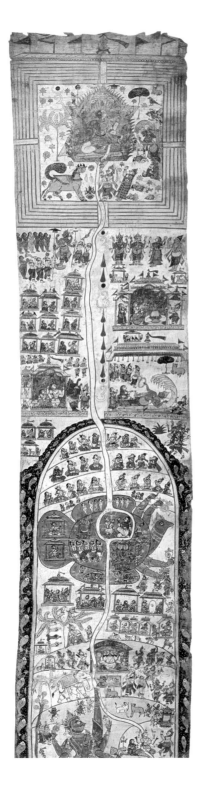
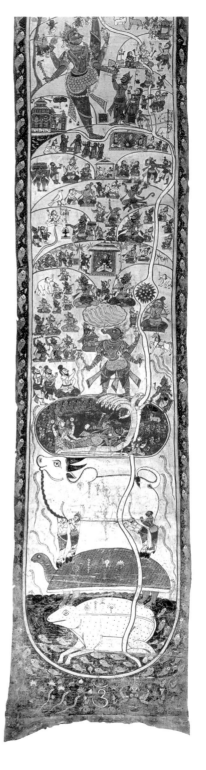

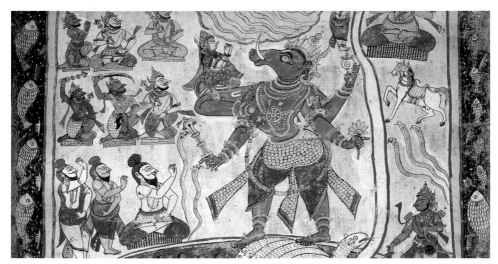

(detail)

swimming upward in blue waters to join in an arch just above the giant bird Garuda, Vishnu's mount. Also, instead of Ganesha, an androgynous form of Vishnu and his wife, Lakshmi, appears at the beginning of the scroll. A river begins its journey at the left foot of the deity and meanders all the way to the cosmic ocean at the bottom. Among the other interesting figures in the square, sacred space at the top are Vishnu as Narayana recumbent on his serpent couch, on one side, and the Kamadhenu, or cow of desire, and the adoring monkey Hanuman, below. That the latter is present instead of Garuda points to connections with Rama, an avatar of Vishnu, to whom Hanuman is devoted, and with the Andhra scroll, where Hanuman also stands behind Narayana.

Garuda is presented in the next prominent vignette, however, as a cosmic bird holding Vishnu's attributes with his four hands (see detail on page 43). Clearly he is identified here with his divine master. Cosmic and cosmological meanings are also inherent in one of the next important scenes, where we encounter both Vishnu's supine Narayana form and the great Varaha (boar) avatar, the manifestation in which the god rescued the sinking earth. Only the head here is that of the animal (see detail above).

Lower still are three animals standing on one another's backs in the cosmic ocean. The bottommost creature is too stylized to recognize easily, but the one in the middle is the tortoise, which in Indian cosmology is said to support the universe and is also the second of Vishnu's avatars, as is clear from the few emblems of the god on his shell. The third is a fine representation of a bull, symbolizing dharma, the order that supports the cosmos. Interestingly, the bull's four legs are constituted of humans representing the four castes of Hinduism: (from left to right) brahman (priests), kshatriya (warriors), vaisya (merchants), and sudra (laborers). The space beyond these prominent compositions is filled with various narrative scenes depicting gods, humans, and animals engaged in diverse activities that are too numerous to be identified here.

P. P.

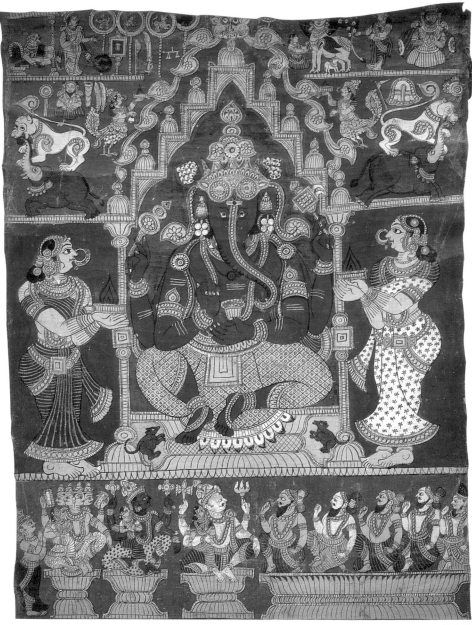

17 | *A Narrative Scroll with Hindu Myths*

Andhra Pradesh, Telangana, c. 1875

Ink and pigment on cloth; 757 x 91.4 cm

Gift of the Nathan Rubin–Ida Ladd Family Foundation, 2000.491

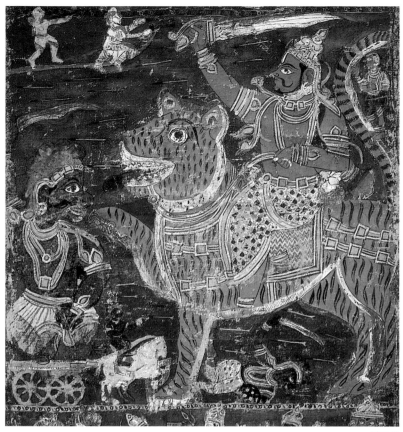

(detail)

This nineteenth-century scroll from the Telangana region of Andhra Pradesh is a survivor of the ancient tradition of using illustrated scrolls as aids in the telling of stories. (Another in the collection is from Orissa; see cat. no. 16.) Its exact textual or oral origin is not easy to determine, but generally the stories represented on scrolls of this type are from the Telegu versions of the *Ramayana* or the *Mahabharata*. While some of the images may reflect Hindu mythologies, others may refer to local legends and folktales. Whatever its source, this scroll, with its typical division into horizontal registers and its red background, is rich in human, divine, demonic, and animal forms.

At the top of the scroll is Ganesha, the elephant-headed god of auspicious beginnings (see detail on page 46). Adorning his shrine are typical motifs: lions attacking elephants *(gajasimha)* and a stylized lion's head known as a face of glory *(kirtimukha)*. Celestials in the form of half-human, half-avian creatures adore him on either side of the arch above; two rats at the base look up eagerly for a crumb or two from his bowl of sweets.

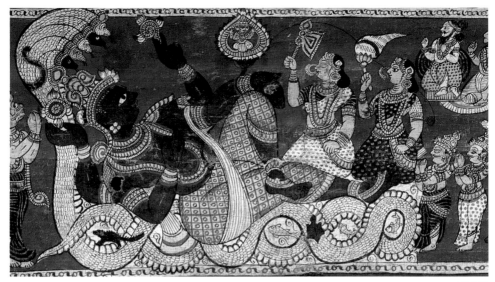

(detail)

Interesting also is the Kamadhenu, or cow of desire—with a human head and wings—at the top right, being adored by mortals. Elsewhere in the scroll, another composite mythical beast, the two-headed eagle known as the Gandabherunda, appears, symbolizing supreme strength. Holding serpents with its beaks, the creature effortlessly carries lions and elephants as it flies through the air.

The tiger appears several times in the scroll. In one scene it carries a sword-brandishing hero who engages a black, demonic figure of cosmic proportions riding a tiny chariot drawn by a white steed with a child driver (see detail on page 47). Among the many animals whose presence aids us in identifying their divine masters, those associated with one of two eminent representations of the cosmic Vishnu as Narayana are particularly interesting.

In the first scene (see detail above), the god lies on his usual serpent couch in the milk ocean (hence the white water), which is inhabited by all sorts of aquatic creatures. Behind the hood of the serpent stands the monkey Hanuman, the devout associate of the god Rama, one of Vishnu's avatars. In the second, rarer depiction, Vishnu's couch is a banyan leaf rather than the cosmic serpent. Below, against the milky ocean, are four elephants who may symbolize the four directions (dikgaja). Between them a formation of stylized yellow rocks represents a mountain supported by a tortoise, which may allude to Vishnu's second avatar, whose reptilian form he assumed (in another episode from Hindu mythology) to support the stick for the churning of the ocean that created the universe.

P. P.

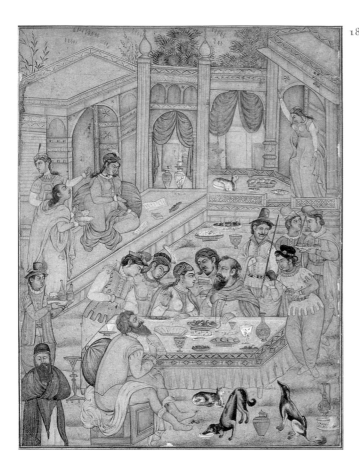

18 *European Banquet Scene*
Mughal, c. 1600
Opaque watercolor and gold
on paper; 42.5 x 29.2 cm
Lucy Maud Buckingham
Collection, 1919.891

In this version of a New Testament subject, the Marriage at Cana, a Mughal artist included a motif he had seen in European prototypes: domestic animals at large banquets. Saluki hounds grace the area near the table, and two cats sit, sphinxlike, one near the dogs and the other in the background.

The third Mughal emperor, Akbar (r. 1556–1605), was fascinated by European culture and Christianity. He is known to have had his court artists copy engravings of European paintings as exercises for assimilating Western techniques of perspective and rendering volume and facial expression. Here, the artist worked in one of several styles used for interpreting European subjects, *nim qalam* (literally, "half-pen") style, so named because the ink drawing is only partly filled with light washes of color. The source of this painting, and its two Salukis, may have been a composition by a Venetian artist such as Paolo Veronese (1528–88).

B. S.

ANIMALS IN DAILY LIFE

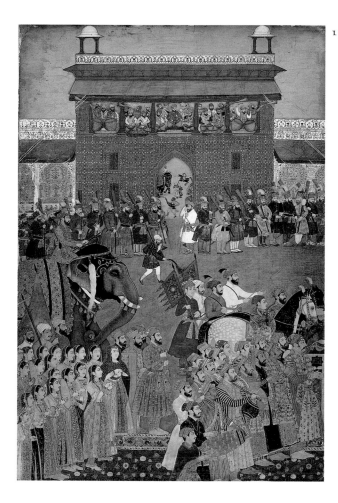

19 | *Illustration from the* Padshahnama

Mughal, mid-seventeenth century
Opaque watercolor and gold
on paper; 38.5 x 26.7 cm
Kate S. Buckingham
Endowment, 1975.555

In India the elephant has always been preferred to other animals for the display of power, pomp, and pageantry. Thus, the fifth Mughal emperor, Shah Jahan (r. 1627–58), was merely following established practice when he chose to ride his favorite elephant, Mugarak Manzil, into Agra on January 28, 1628, after removing all other claimants to the imperial throne. This painting depicts that event as it was recounted in Shah Jahan's memoirs, the *Padshahnama*. Together, the royal rider and his regally adorned mount constitute a mobile bastion of majesty. Preceded by flag bearers and riderless horses, Shah Jahan proceeds authoritatively through an impressive, beautifully dressed crowd. But the emperor is not merely a passenger, riding in a howdah (a seat on the back of an elephant); rather, his impressive authority is indicated by his presentation as a mahout (elephant handler), comfortably astride and in complete control of the massive beast beneath him.

B. S.

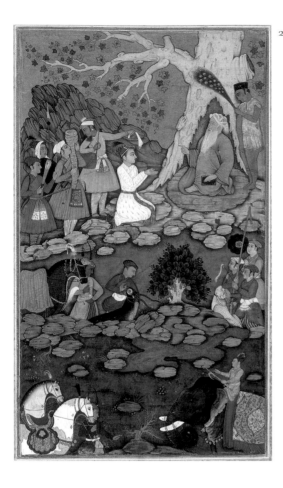

20 | *Prince Visiting an Ascetic during a Hunt*
Kashmir, 1625/50
Opaque watercolor, gold, and ink on paper;
40.5 x 26.7 cm
Kate S. Buckingham Endowment, 1995.267

In the center section of this folio, courtiers divert the attention of a buck and a cheetah from each other until a prince, in the top section, completes his obeisance to a holy man and the hunt can proceed. The bejeweled nobleman has detoured his hunting party to pay homage to an ascetic, whose high esteem is indicated by the person fanning him with a peacock fly whisk. In the bottom register, the royal mounts—horses and an elephant—held in check by their attendants almost seem to be challenging one another as to which is the best equipped, and costumed, to carry the prince into the fray. The image serves to document the prince's moral integrity and humility, which he balances with his military and hunting accomplishments. Historically, sport and military activity, both of which involved similar equipment— arms and animals—often overlapped. When conflict occurred in the Mughal Empire, a ruler would often organize a hunting expedition as a pretext for marching a fighting force into the troubled area. The implied threat of this action would be enough to resolve the problem.

B. S.

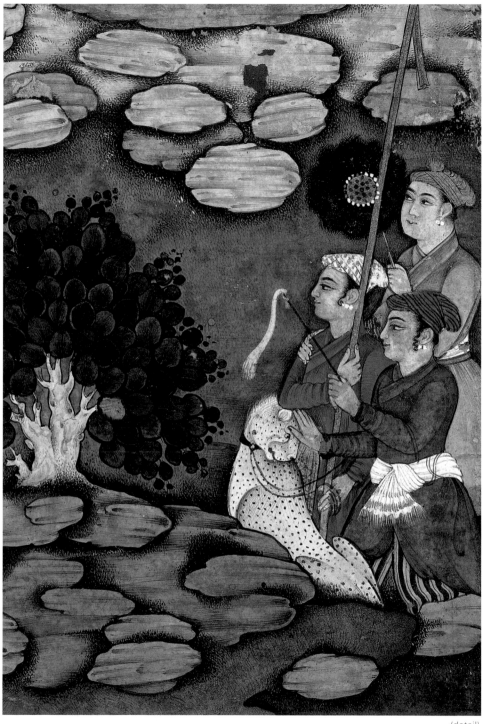

(detail)

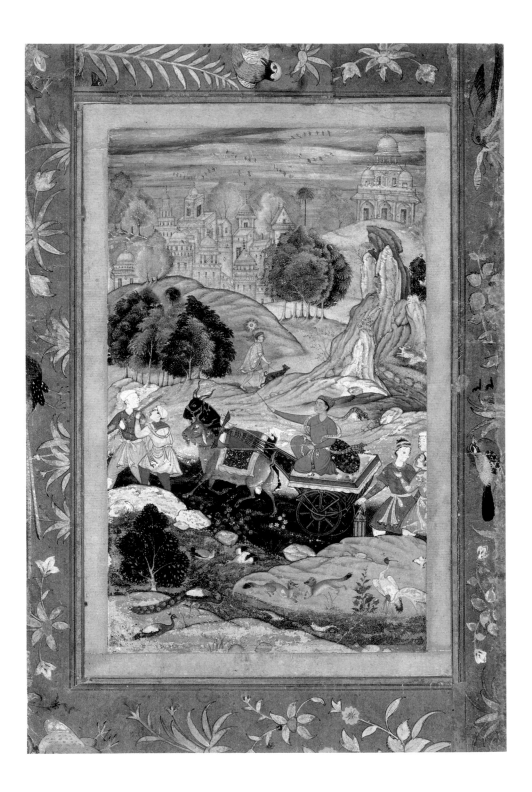

21 | *Album Page*

Mughal, c. 1585 (central image); Rajasthan,
late seventeenth/early eighteenth century (border)
Opaque watercolor and gold on paper; 28 x 18.3 cm
Lucy Maud Buckingham Collection, 1919.950

Foxes frolicking alongside birds in a setting filled with other animals indicate that this is an idealized landscape where the proverbial lion and lamb peacefully coexist. The page is populated with pairs of animals: a peacock and his hen, fish in the stream, a couple of red-headed herons, the aforementioned foxes, a goose and her gander, and scampering rabbits in the hills. Colorful birds nesting in the pieced border further enhance the menagerie effect. A young nobleman commands a goat-drawn cart along a path that skirts this paradise. Ahead of him, a wandering sannyasin (Hindu ascetic) moves through an expanse of exquisitely rendered green hills, forests, and craggy rock formations toward palatial, white buildings in the distance.

Although this painting is not from a known *Akbarnama*, the illustrated autobiography of emperor Akbar (r. 1556–1605), the princely figure resembles that Mughal ruler. Early in his reign, Akbar questioned his moral responsibilities as he sought the right path for his imperial journey. He summoned men of all faiths to assist him with his spiritual quest. This painting may represent that period of Akbar's sovereignty. The princely figure is strangely isolated from his attendants. He urges the sturdy draft animals to pull his cart past men bickering over a rifle. Perhaps only he and the sannyasin are aware of the celestial realm that awaits them.

B. S.

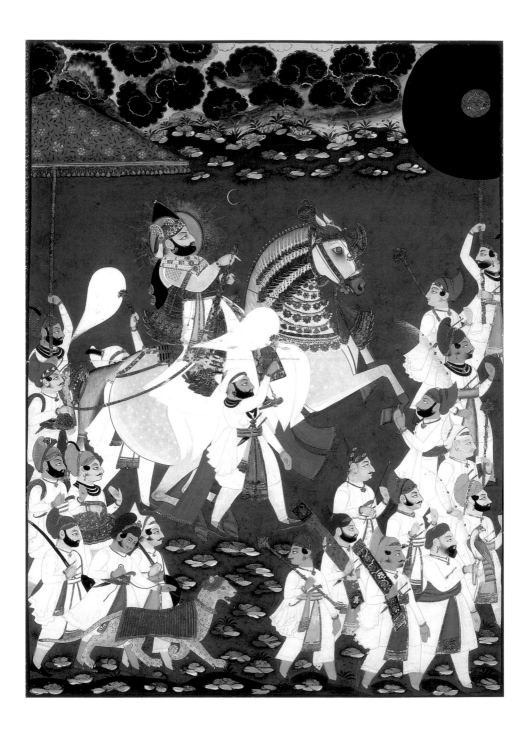

| *Maharana Bhim Singh*

Attributed to Ghasi (active 1820/36)
Rajasthan, Mewar, Udaipur Royal Atelier, c. 1820
Opaque watercolor and gold on paper; 60.7 x 45.6 cm
Everett and Ann McNear Collection, 1975.507

In India a taste for magnificent accoutrements characterizes the regal aesthetic. An idealized horse, fully caparisoned and bedecked with ceremonial regalia, can be seen as a sort of energized, mobile throne. Here, the harmonious alliance between Maharana Bhim Singh (r. 1778–1828) and his steed symbolizes imperial leadership: the discipline essential for expert horsemanship indicates the ability to rule. However, this is more public relations than fact, for Bhim Singh was considered a "weak-willed hedonist" who had to accept British protection in 1818 to rescue him from hard times. Restored to wealth by the end of his reign, he enjoyed high living and frivolity. Portraits from that period, such as this one, glorify his reclaimed grandeur.

The image evokes not only the ruler's ostentatiousness but also his love of the hunt, indicated by the presence of a now-extinct form of cheetah *(Acinonyx jubatus)*. This species, also known as hunting leopard, was collected and trained to hunt by Indian nobility in much the same manner as was the falcon (see cat. no. 23). As the hunting party approached its prey, the cat would be distracted and hooded. Once within suitable range of the game—usually a species of antelope or black buck—the hunting leopard would be pointed in the right direction and unhooded. The chase was considered thrilling; as one prince recollected, "In cheetah hunting, one sees two of the fastest animals in the world competing with each other, one for its food and one for its life, in the most graceful and exciting manner." A speedy pursuit by the cheetah of his prey and the kill that followed can be seen as another metaphor for the might of kingship.

B. S.

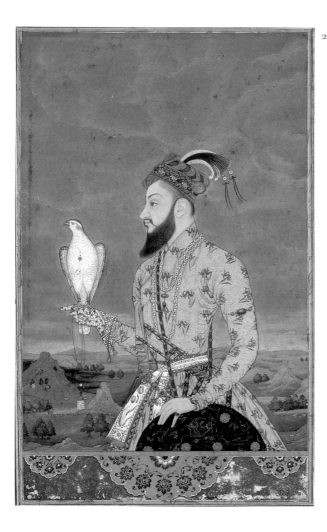

23 *Azam Shah, Son of Aurangzeb*
Deccan, Mughal style, 1660/75
Opaque watercolor and gold on
paper; 31 x 19.4 cm
Gift of Guy H. Mitchell, 1926.330

The thrill of seeing a falcon devastate its prey (mostly other birds, but also hares and occasionally ravine deer) was considered symbolic of the rights of kings. Thus, the falcon was incorporated into imperial Indian portraits in the early seventeenth century and, by the eighteenth century, became a popular motif. In this image of Azam Shah, son of the sixth Mughal emperor, Aurangzeb (r. 1658–1707), man and bird share physical qualities. Both are profiled, with the sharp features of the prince echoing the menacing beak of the falcon, and both sport plumage. Training a falcon was a matter of honing and taming the natural instinct of a predator. Here, all the accoutrements of falconing—quilted glove, collared leash, dagger, and sword— are ornately decorated with gold and gems, illustrating the Mughal taste for embellishing even utilitarian objects to express delight in the physical world.

B. S.

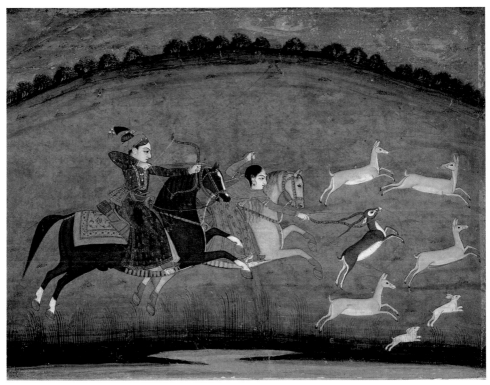

24 | *Prince and Princess Hunting*
West Bengal, Murshidabad, c. 1760
Opaque watercolor and gold on paper; 17.7 x 22.6 cm
Everett and Ann McNear Collection, 1978.153

Galloping across a verdant plain, a prince and princess are engaged in a favorite royal pastime—the hunt. The princess leans into her horse's stride and gracefully extends forward to catch a buck with her bow. The prince pulls himself upright to release a sharp arrow to kill his prey. The royal figures may represent Baz Bahadur, the sultan of Mandu who was defeated by Mughal forces in 1561, and his beloved, Rupmati. Popular with late-Mughal painters, they are often portrayed riding and hunting in a landscape. Unlike the formal illustrations of hunting parties that typically fill Mughal and Rajput albums, this image of the couple's hunting expedition is intimate; alone with each other, they amuse themselves with the pursuit of these gentle beasts. The momentum of all the players being propelled across the page toward a foreordained climax gives this painting a strong undercurrent of sexual energy.

B. S.

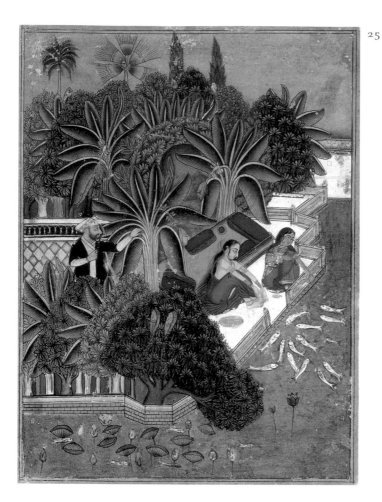

*Royal Women
Feeding Fish*

Rajasthan, Bundi, c. 1740
Opaque watercolor on
paper; 28.5 x 22 cm
Everett and Ann McNear
Collection, 1998.189

In the torpor of the monsoon season, beautiful young women loll at the water's edge, tantalizing both the fish they feed and a hidden admirer. Feeding fish, a popular zenana (harem) activity at this time of year, can be viewed as a metaphor for nature's fecundity and renewal by regenerative rainfall, which replenishes ponds and streams so fish can spawn there. (A once-dry waterway provides a propitious spawning ground, for fresh water does not harbor any of the predators that might destroy fish eggs.) The fish is an ancient symbol of fertility and abundance as well as auspiciousness in Indian culture. The painting contains other motifs among the thick foliage that allude to abundance: banana trees heavy with ripe fruit, and a limb in full foliage overhanging the balustrade.

B. S.

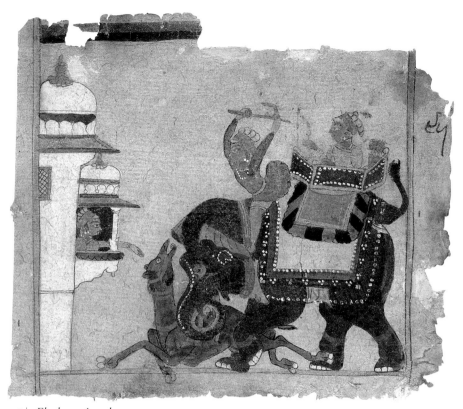

26 | *Elephant Attack*

Rajasthan, Marwar or Sirohi, second half of the seventeenth century
Opaque watercolor on paper; 18.7 x 21.3 cm
RX 20766/540

As the thick-skinned elephant is the largest living land animal (even the camel appears diminutive in comparison), it has little to fear from other animals; hence, its characteristic placid demeanor. Thus, an attacking elephant would have been both cause for alarm and thrill-producing entertainment. While elephant fights were often staged at the Mughal and Rajput courts and commemorated in pictures (see cat. no. 27), a duel between a camel and a pachyderm is a rare subject in Indian painting. (Two camels fighting would be more likely.) Here an elephant, egged on by an aggressive mahout (elephant handler) who sits in front of a prince in a howdah (a seat on the back of an elephant), attacks a camel as a woman watches from her porch. While the folkish image appears fanciful, in the desert states of Rajasthan, a staged or accidental fight between these two large animals could have occurred. Whether this painting depicts an actual or imaginary event or illustrates a popular tale remains unknown.

B. S.

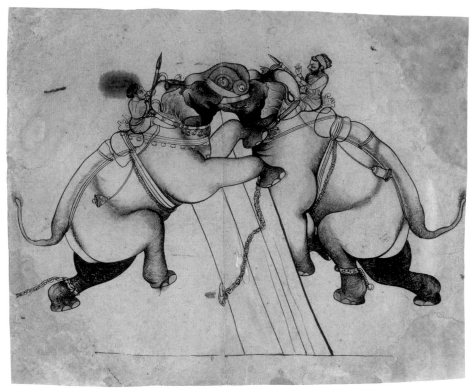

27 | *Two Charging Elephants*

Rajasthan, Kotah, c. 1730

Ink and white paint on paper; 28.9 x 35.8 cm

RX 20766/520

Staged elephant combats—a favorite Rajput court entertainment—were often documented, especially by artists from Kotah. Spectators cheered for particular animals and their mahouts, specialists in elephants' health, grooming, and even psychology. Controlled by leg irons, normally docile elephants were prodded with iron goads to attack each other from either side of a thick and high dividing wall of earth that ran the length of the courtyard. Eventually, the barrier would come down; if the contest became overly savage, the com-batants would be separated by a weapon called a *charkhi* (see cat. no. 28). Here, elegant calligraphic lines suggest the massive elephants' grace, as well as their strength and ferocity. The pattern created by their interlocking tusks (blunted for sport) and their rolled trunks is not a mere artistic conceit. Contrary to popular belief, the elephant's trunk is actually too delicate to be an instrument of battle. Whether on the offensive or defensive, the animal will curl his trunk to protect its delicate underside.

B. S.

28 | *Taming a Berserk Elephant*

Rajasthan, Kotah, nineteenth century
Opaque watercolor, ink, and betel juice(?) on paper; 16.5 x 21.3 cm
Wayne Hartwell Bequest, 1975.524

The gory mayhem depicted here—caused by an out-of-control elephant—is enhanced by splotches of red pigment (possibly spat betel juice). A trampled horse has thrown his now-beheaded rider, while another bloodied victim has relinquished his shield. Skewered by the berserk elephant's tusk, a third man loses his grip on his *charkhi*—a hollowed-out bamboo stalk affixed to a long pole, partitioned in the center, and filled with gunpowder on either side—which would have been used to frighten the animal into submission. When ignited on both ends, the *charkhi* would spin, spitting fire and crackling loudly. Sketched in at the right is the next line of attack: like picadors at a bullfight, these men are about to charge with spears; to the pachyderm (literally, "thick skin"), however, this may be no more irritating than being pricked by cocktail forks. The inscription reveals that the elephant's name was Gajanandana. Holes in the paper indicate that the image was intended to be transferred using a stencil technique called pouncing.

B. S.

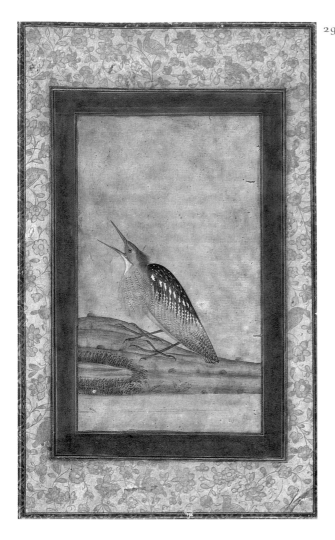

29 | *Album Page: Study of a Pond Heron*

Mughal, seventeenth century or later
Opaque watercolor on paper;
37.8 x 23.7 cm
Gift of Ganeshi Lall, 1927.341

The Pond Heron is named for its choice of habitat, which here is shown surrounded by delicate grasses. Unlike its more flamboyant relative, the long-legged Grey Heron (see cat. no. 31), it is a small, quiet marsh bird that uses its voice primarily for mating. Here, the open beak and full feathers indicate the mating season. This carefully observed rendering is typical of those created during the reign of the Mughal emperor Jahangir (r. 1605–27).

Jahangir's curiosity about the natural world led to his commissioning precise, portraitlike renderings of creatures that captured his fancy (and that as often he captured for his private zoological garden). His scientific and artistic inquiry preceded by at least a century a similar bent among the British, who also collected and documented the "picturesque" fauna of India when they colonized it.

B. S.

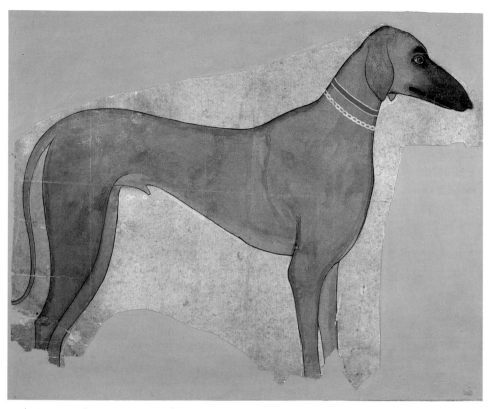

30 | *Portrait of a Rampur Hound*
Style of Swarup Ram (active c. 1800)
Rajasthan, Mewar, Udaipur(?), 1780/1820
Watercolor and ink on paper; 32.7 x 42 cm
Gift of Mr. and Mrs. James W. Alsdorf, 1987.361.4

Hindus generally find dogs distasteful, and Muslims consider them unclean. However, the usefulness of the hound in hunting helped both maharajas and Mughal emperors rationalize away their disgust for the animal. Some royals even came to admire their four-legged hunting companions, so much so that they commissioned portraits of them. This particularly realistic and handsome study may represent the favorite hound of a prince at Udaipur. The Rampur Hound (also known as the North Indian Greyhound, Rampuri, or Rampur Greyhound) is a member of the sight-hound group that is indigenous to northwestern India. Its paws (missing here) are characterized by distinctive webbing that facilitates moving over many types of terrain. The hound's ability to focus on its prey, as well as its speed, keen vision, and tolerance of hot weather, make it an outstanding companion to the falcon for coursing game such as hares, foxes, black bucks, and boar.

B. S.

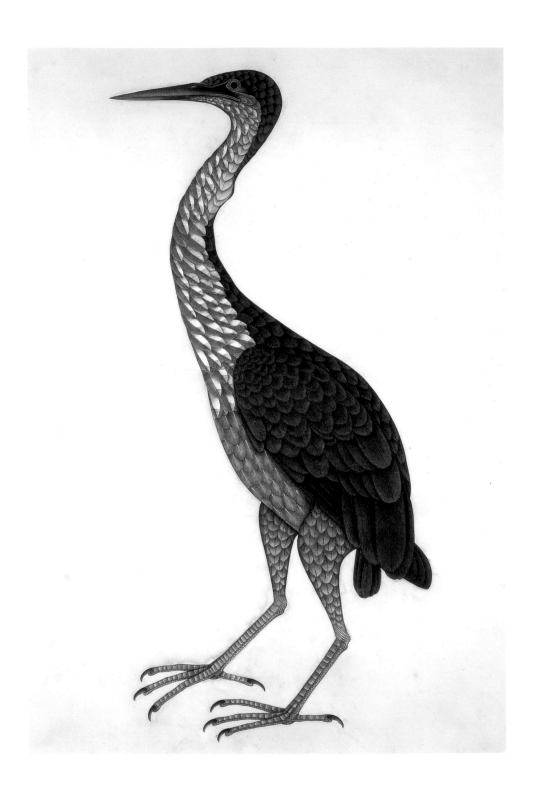

West Bengal, Calcutta, India Company School, 1780/1820
Watercolor on European watermarked paper; 59.1 x 46.4 cm
Gift of Charles C. Haffner III, 1995.259

The heron is not a dive-and-swoop hunter like the falcon. Rather, it will spend much of its time wading—and waiting—for the optimal moment to use its pincer beak to secure a supper of fish and other wetland delicacies such as frogs, crabs, spiders, and insects. When the heron is ready to fly, it will fold its long neck gracefully back into its shoulders. At breeding time, the male's already elegant feathers will be enhanced by luxurious additions to his breast and back, and crested plumage resembling a turban ornament will appear on his head. The heron is a villain in a story from the *Panchatantra*, five volumes of animal fables with moral overtones, such as those of Aesop, that were written to teach wise conduct to princes; in the tale, the bird sweet-talks fish into trusting it—long enough to be gobbled up.

In the eighteenth century, due to the decline of the Mughal empire, many Indian artists who had worked in its ateliers turned for support to the new British ruling class, thus beginning the India Company School, so named for the patronage role played by members of the British East India Company. Among the first patrons was Sir Elijah Impey (1732–1809), Chief Justice of the Supreme Court in Calcutta. Sir Elijah commissioned Indian painters to document wild birds and other exotic animals in the menagerie his wife had created in their garden. A heron such as this may have been among them.

B. S.

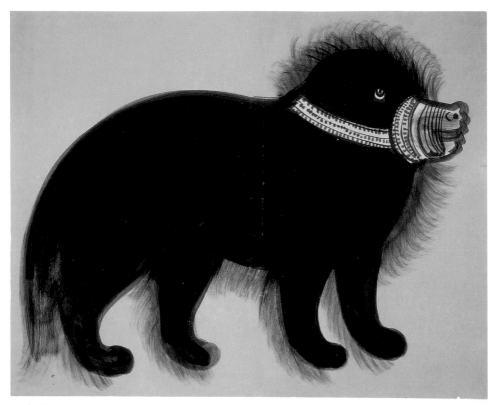

32 | *Bear*

Tamil Nadu, Tanjore, c. 1910
Watercolor on paper; 33.1 x 41.4 cm
Gift of Mrs. Carolyn Wicker, 1939.344

An affectionate feeling pervades this depiction of a performing bear, whose muzzle was probably as much decoration as it was protection for village audiences. They paid the animal's mendicant master for the entertainment with food, cloth, or money. Painted in Tanjore (now Thanjavur), a famous temple city in Tamil Nadu, the image probably belonged to a series representing the various trades and professions of the region. Such series were particularly popular with Europeans, who took them home as souvenirs. The animal's alert expression and interested gaze individualize this sympathetic rendering of what is most likely a Sloth Bear. Indigenous to the dry forests of south India, this insect-eater has huge feet and claws, which allow it to open termite nests, and funnel-like lips, which permit it to inhale its prey. To suggest its shaggy coat, the artist employed a dry-brush technique.

B. S.

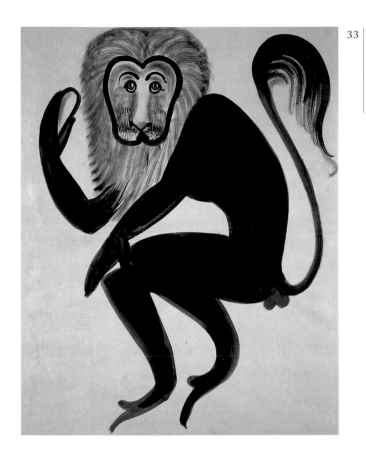

33 | *Baboon*

Tamil Nadu, Tanjore, c. 1910
Watercolor on paper;
41.5 x 33 cm
Gift of Mrs. Carolyn Wicker,
1939.345

This sheet probably originated as part of a series popular with tourists. The baboon is one of the larger members of the monkey genus *Papio*. It has an elongated muzzle and uses all four limbs for mobility. Males have a leonine mane. Baboon behavior exhibits so many human traits, particularly in family organization, that it is often seen as a human analogue. Although not dressed for a public appearance, this baboon may have been a performer. He gazes out soulfully, about to take a bite of banana. The bright-yellow fruit and the animal's ruddy rump provide vibrant counterpoints to its dark, simian form. The artist detected in the baboon's posture a similarity to calligraphy, which he emphasized with the elegant curve of the animal's tail, characteristically almost as long as its body.

B. S.

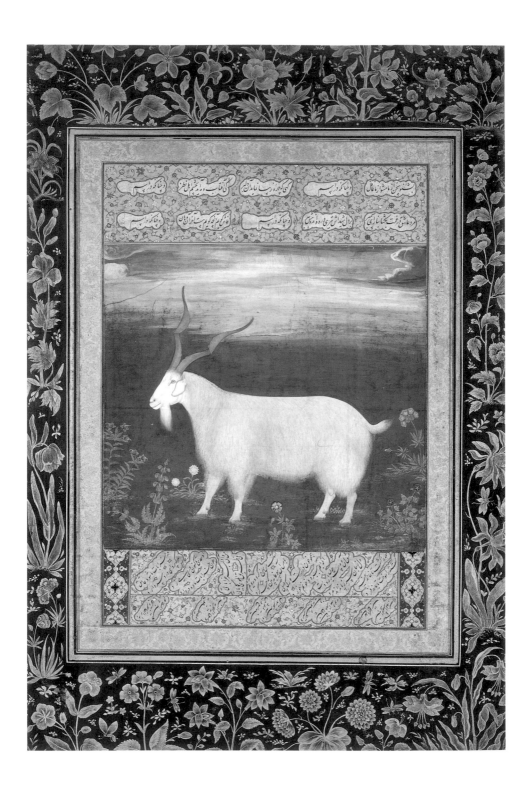

Album Page: Portrait of a Goat

Mughal, early seventeenth century
Opaque watercolor, ink, and gold on paper; 37.9 x 25.6 cm
Lucy Maud Buckingham Collection, 1919.944

Most likely sketched from a live model, this is not a generic goat but a specific creature whose individuality—silky coat, sculpturally twisted horns, and peculiarly intelligent facial expression—was recorded with the faithfulness to nature demanded of artists in the atelier of the Mughal emperor Jahangir (r. 1605–27). The animal may be a shawl goat collected for Jahangir's private zoo.

A species of mountain goat that flourishes in Tibet, the shawl goat provides one of the most luxurious of all animal fibers, the soft wool that the world knows as cashmere, so called for its use in the famous shawls made in Kashmir. A purebred goat produces less than four ounces per year of the soft down that grows beneath its longer and coarser outer hairs. In springtime it is either combed out through an arduous process or is gathered after the goats rub against rocks and shrubbery, leaving a deposit of precious fibers. For centuries the trade in cashmere between Tibet and Kashmir has been fiercely guarded. In the early nineteenth century, British entrepreneurs moved goats to Bengal and to Scotland with the intention of producing cashmere there. In both locales, the goats—removed from their cool mountain habitat—lost their glorious coats.

B. S.

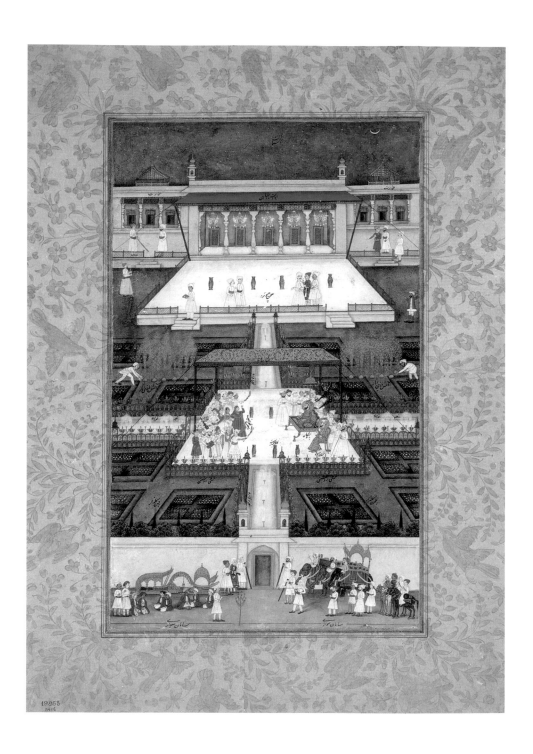

Dancing in a Palace

Uttar Pradesh, Oudh, Mughal style, early eighteenth century
Opaque watercolor and gold on paper; 40.6 x 29 cm
Lucy Maud Buckingham Collection, 1919.953

Gliding amid blossoms and perching on branches, golden birds animate the elegant border of this sumptuous court scene. The border's soft green hue and fluid forms contrast sharply with the rigid centrality and minute detail of the central image, and yet the framing device extends the space in which the scene it surrounds takes place. This painting is an example of the "palace-scapes" that were popular in the eighteenth century in India, modeled, perhaps, on European perspective drawings, which were known to artists of the court ateliers.

While the requisite limousines of state—elephants and horses—wait in the foreground, festivities proceed behind the walls. In the middle zone, under a canopy set in a grand, geometrically arranged garden, a monarch and his court enjoy a performance of music and dance as fireworks burst forth in the clear, starlit sky. That the birds in the border are drawn in gold seems to suggest that they brighten the sky in their natural way as much as the pyrotechnics do artificially.

B. S.

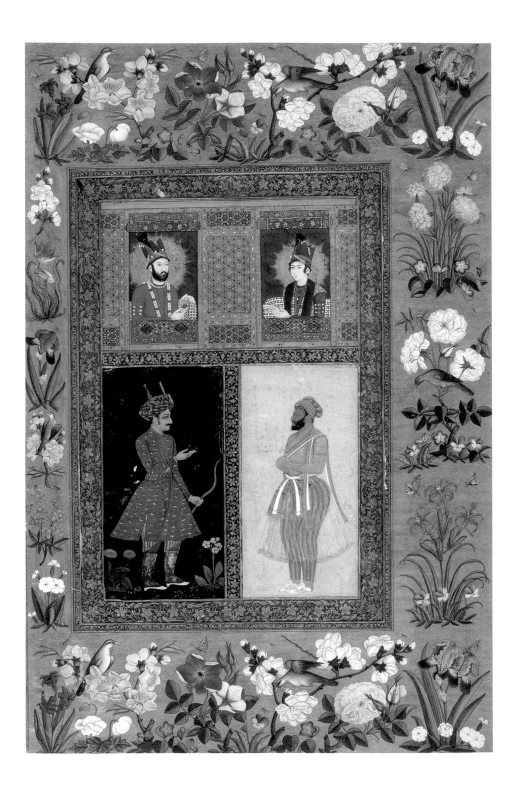

| *Four Portraits in a Border with Flowers and Birds*

From the Leningrad Album
Style of Muhammad Sadiq (active 1740/1800) (border)
Mughal, mid-eighteenth century (border and upper portraits);
mid-seventeenth century (lower portraits)
Opaque watercolor and gold on paper; 47.4 x 30.8 cm
Lucy Maud Buckingham Collection, 1919.952

The irises, lilies, and blossoming fruit branches in this exquisite Mughal album border are varied and painted with scientific precision. The birds, however, appear generic. Perhaps included to embellish upon the flowering plants' environment—one in which fluttering insects spread pollen and birds feast on the blooms' nectar and on insects—the birds cannot be identified by their forms or the shade of their plumes. In fact each appears to be based on the same model and differentiated only by the color of its wings, apparently determined by the artist to complement the hues of the surrounding flowers. Noteworthy is the duplication of the top and bottom borders; a creative variety occurs in the side panels.

This glorious garden frames four portraits, each of which is contained within an elaborate border of Islamic geometric patterns. The bust at the top left represents Nadir Shah (1688–1747), famous for having sacked Delhi in 1739. To the right is a portrait of his son, Adil Shah. The two turbaned men below have not been identified; they seem to confront each other, a sense that is enhanced by their differing facial types, body language, and dress. The mustachioed man on the left, garbed in heavy, richly patterned clothing typical of northern regions, gestures toward the bearded, dark-skinned man opposite, who wears a sheer garment that would be appropriate for the warmer climate of the subcontinent.

B. S.

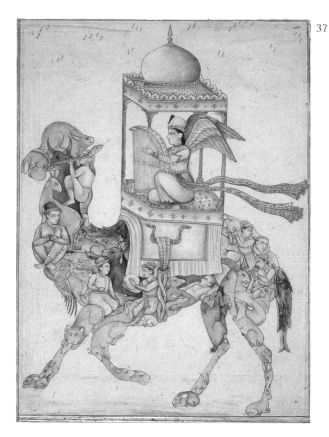

37 | *Composite Camel with Peri*
Mughal, c. 1700
Ink wash, gold, and color on paper;
25 x 18.4 cm
Everett and Ann McNear Collection,
1981.219

Composing this jigsaw puzzle of interlocking humans and animals to form the body of a camel was as much a game for the artist as deciphering it is for the viewer. Composite beasts have long figured in India's visual culture, but only in Mughal paintings are these images so complex. As was common, the camel's legs constitute a kind of Darwinian food chain, with animals flowing out of (or into) the mouth of a larger one. As was also typical, the camel's passenger is a harp-playing peri (a fairy or fallen angel). She is accompanied by musicians, who are incorporated into the camel's body. Among the other human elements are men in European costumes that were popular a century earlier, indicating that these were often-copied motifs. Seen on the camel's hind quarters is a hatless man in an Elizabethan collar. His inelegant placement may suggest that, however fanciful, this composite image also may have had a satiric political meaning.

B. S.

38 | *Album Page with Calligraphic Exercise and Animal Border*
Provincial Mughal, late seventeenth century (border);
Persia, sixteenth century (calligraphy)
Opaque watercolor, ink, and gold on paper; 22.8 x 36.4 cm
Gift of Guy H. Mitchell, 1926.326

The leaping animals in the border of this page—four deer, a fox, a lion attacking a horse, and another lion pouncing on an ibex—are rendered with the expert attention to animal behavior that was characteristic of painters in the imperial Mughal ateliers. While they lack some of the grace and naturalism that those artists were able to achieve, the bounding creatures remind us that in nature animal predators are as dangerous as human hunters. Originally, this page may have been included in a book of Arabic proverbs. The line of calligraphy translates, "He who has a sweet tongue has many brothers." This is followed by a word that means "And he said," which introduces the quotation (now missing) that would have followed. Without more text, it is difficult to surmise a relationship between the words and the border, beyond the fact that the calligraphy was treasured enough to be preserved and embellished in an album.

B. S.

SELECTED BIBLIOGRAPHY

Ali, Salim. *The Book of Indian Birds*. 12th ed. Bombay: Bombay Natural History Society and Oxford University Press, 1996.

Ambalal, Amit. *Krishna as Shrinathji: Rajasthani Paintings from Nathdvara*. Ahmedabad: Mapin, 1987.

Banerjee, P. *Rama in Indian Literature, Art and Thought*. Vol. I. New Delhi: Sundeep Prakashn, 1986.

Beach, Milo Cleveland. *The Imperial Image: Paintings for the Mughal Court*. Exh. cat. Washington, D.C.: Freer Gallery of Art, Smithsonian Institution, 1981.

Das, Asok Kumar. *Mughal Painting during Jahangir's Time*. Calcutta: The Asiatic Society, 1978.

Dehejia, Vidya, ed. *The Legend of Rama: Artistic Visions*. Bombay: Marg Publications, 1994.

Del Bonta, Robert. "Reinventing Nature: Mughal Composite Animal Painting." In *Flora and Fauna in Mughal Art*, edited by Som Prakash Verma. Mumbai: Marg Publications, 1999.

Desai, Vishakha N., *Life at Court: Art for India's Rulers, 16th–19th Centuries*. Exh. cat. Boston: Museum of Fine Arts, 1985.

Dharmakumarsinhji, R. S. "Reminiscences of Indian Wildlife," http://www.felidae.org/LIBRARY/dharmakumarsinhji.html. Newbury, Berkshire: The Nature Conservation Bureau Ltd., 1992. © 1992 Maharani Kumud Kumari.

Divyabhanusinh. *The End of a Trail: The Cheetah in India*. New Delhi: Banyan Books, 1995.

Ebeling, Klaus. *Ragamala Painting*. Basel, Paris, and New Delhi: Ravi Kumar, 1973.

Fischer, Eberhard, and Dinath Pathy. "Traditional Painting." In *Orissa Revisited*, edited by Pratapaditya Pal. Mumbai: Marg Publications, 2001.

Gangoly, O. C. *Ragas and Raginis: A Pictorial and Iconographic Study of Indian Musical Modes Based on Original Sources*. Bombay: Nalanda Publications, 1948.

Getty, Alice. *Ganesa: A Monograph on the Elephant-faced God*. Oxford: Clarendon Press, 1936.

Gorakshakar, Sadashiv, and M. L. Nigam. *MRIGA: Animal* [sic] *in Indian Art*. Exh. cat. Tokyo: Yomiuri Shimbun, 1988.

Goswamy, B. N., and A. L. Dallapiccola, et al. *Krishna the Divine Lover*. London: Serindia Publications, and Boston: David R. Godine, 1982.

Harris, Lucian. "Archibald Swinton: A New Source of Albums of Indian Miniatures in William Beckford's Collection." *Burlington Magazine* 143, no. 1179 (2001): pp. 360–66.

Kauffmann, Walter. *The Ragas of North India*. Bloomington: Indiana University Press, 1968.

Mair, Victor H. *Painting and Performance*. Honolulu: University of Hawaii Press, 1988.

Mason, Darielle, et al. *Intimate Worlds: Indian Paintings from the Alvin O. Bellak Collection*. Philadelphia: Philadelphia Museum of Art, 2001.

Mittal, Jagdish. *Andhra Paintings of the Ramayana*. Hyderabad: Andhra Pradesh Lalit Kala Akademi, 1969.

O'Flaherty, Wendy Doniger. *Hindu Myths: A Sourcebook Translated from the Sanskrit*. New Delhi: Penguin Books, 1975.

Pal, Pratapaditya. *Ragamala Paintings in the Museum of Fine Arts, Boston*. Exh. cat. Boston: Museum of Fine Arts, 1967.

——. *Elephants and Ivories in South Asia*. Los Angeles: Los Angeles County Museum of Art, 1981.

——. *Indian Painting: A Catalogue of the Los Angeles County Museum of Art Collection*. Vol. I. Los Angeles: Los Angeles County Museum of Art, 1993.

——. *A Collecting Odyssey: Indian, Himalayan, and Southeast Asian Art from the James and Marilynn Alsdorf Collection*. Exh. cat. Chicago: The Art Institute of Chicago, 1997.

——. *Divine Images, Human Visions: The Max Tanenbaum Collection of South Asian and Himalayan Art in the National Gallery of Canada*. Ottawa: National Gallery of Canada, 1997.

——, ed. *Light of Asia: Buddha Sakyamuni in Asian Art*. Exh. cat. Los Angeles: Los Angeles County Museum of Art, 1984.

——, ed. *Dancing to the Flute: Music and Dance in Indian Art*. Exh. cat. Sydney: Art Gallery of New South Wales, 1997.

Rossi, Barbara. *From the Ocean of Painting: India's Popular Paintings, 1589 to the Present*. New York: Oxford University Press, 1998.

Topsfield, Andrew. *The City Palace Museum Udaipur: Paintings of Mewar Court Life*. Ahmedabad: Mapin Publishing Pvt. Ltd.,1990.

Waters, Hope and David. *The Saluki in History, Art and Sport*. New York: Taplinger Publishing Company, 1969.

Welch, Stuart Cary. *India: Art and Culture, 1300–1900*. Exh. cat. New York: The Metropolitan Museum of Art, 1985.

——, et al. *The Emperor's Album: Images of Mughal India*. Exh. cat. New York: The Metropolitan Museum of Art,1987.

——, ed. *Gods, Kings, and Tigers: The Art of Kotah*. Exh. cat. Munich and New York: Prestel-Verlag, 1997.

Williams, Joanna. *The Two-headed Deer: Illustrations of the Ramayana in Orissa*. Berkeley: University of California Press, 1996.